THE
Archive Photographs
SERIES

CANNOCK CHASE
THE SECOND SELECTION

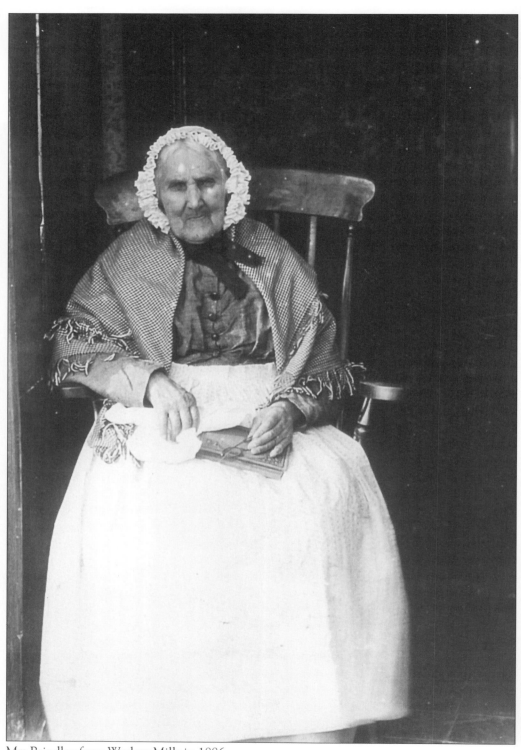

Mrs Brindley from Wedges Mills in 1886.

THE
Archive Photographs
SERIES

CANNOCK CHASE
THE SECOND SELECTION

Compiled by
June Pickerill

CHALFORD

First published 1997
Copyright © June Pickerill 1997

The Chalford Publishing Company
St Mary's Mill, Chalford,
Stroud, Gloucestershire, GL6 8NX

ISBN 0 7524 1076 8

Typesetting and origination by
The Chalford Publishing Company
Printed in Great Britain by
Bailey Print, Dursley, Gloucestershire

Front cover illustration
Anglesey Hotel Bowling Club, Hednesford, in the 1920s

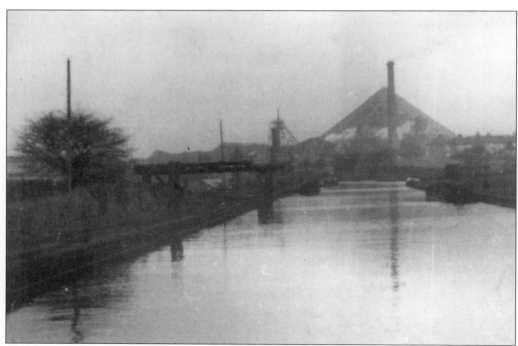

East Cannock canal basin and loading wharf with the colliery in the background, now completely erased from the landscape. The houses are in East Cannock Road and Lower Road.

Contents

Acknowledgements

I would like to thank all the people who gave of their time, shared their knowledge, and generously allowed the use of their precious photographs, without which this book could not have been compiled. In particular, Mrs M. Allen, Mrs D. Barratt, Mr D. Battersby, Mrs S. Belcher, Miss M. Cotterill, Rose Devall, Mr M. Drury, Mr and Mrs A. Dudley, Mrs Dyer (née Heath), Mr D. Earp, Harvena Hall, Mr R. Lycett, Mr B. Morris, Mrs M. Macpherson, Mr W. Nicholls, Mr and Mrs J. O'Leary, Mr D. Pickering, Mr and Mrs C. Schofield, Mr H. Spruce, Mr R. Waterworth, Mr A. White, Mr and Mrs G. White, Mrs J. Williams, Mr and Mrs G. Wright.

For their detective work, Mrs C. Baggott, Mrs M. Hardwick, Mr J. Holston, Mr P. Tranter, St Peter's Knit and Natter Club and also to PrintQuick of Cannock for their quality service.

I apologise in advance for unwittingly leaving anyone off the list, and for any incorrect spelling of the many names that are recorded. The areas covered have been dependent upon the material available, and any further unpublished material that readers might have in their possession, or further information on the subjects contained in the book, would be gladly received.

Introduction

I recently had occasion to talk to someone who had lived locally until leaving school, and had then moved to Dublin. On his return forty years later he spoke of 'Walking through the trees, which were not there when I was a lad, to the top of Hednesford Hills, where we once played football, and where before that Grandad galloped his horses. On a clear day you could see the Wrekin, Wenlock Edge, and Clee Hill. I remember all the pit stacks and slag heaps that once punctuated the horizon, and at that time there was no Post Office Tower. Gone too, thank goodness, is the distant and harrowing sound we frequently heard as we played football; it was the squeal of a pig as it was being slaughtered by the old method.'

His reminiscences set me thinking of all the changes that occur day to day and so gradually, that we lose sight of how we used to live, maybe only ten or twenty years ago. Major changes from small roads to the motorway network influence the way we work and the distances we travel, using our own rather than public transport; from day trips via a 'Chara' to Ludlow - even Blackpool for the daring - to flying to all parts of the world for our annual holiday. There was a shop on every corner, where we stood behind a counter whilst the assistant freshly sliced the bacon on the big red machine and cut the butter and cheese to the required weight, deftly wrapping them in greaseproof paper; collecting from the different shelves behind them all the other goods we wished to purchase, and putting the cost 'on the slate' or paying with real money. Now, most of us travel to the self service supermarket to do a weekly shop, waiting at the check out and paying by cheque or card. We have gone from roaring open coal fires, where we made toast, to gas central heating, and black leaded grates where the dinner was cooked, the kettle was boiled and the iron was heated to all the electrical appliances of a modern kitchen; from draughty windows to double glazing; from formal clothes at the turn of the century to jogging suits, jeans, T shirts and trainers at the millennium.

Gone from the landscape are pit stacks and pit mounds, loads of coal delivered onto the footpath, miners walking home in their 'pit black', the canal with barges full of coal, two military camps with the towns and buses filled with military personnel, row upon row of terraced houses, dance halls, several chapels, fields, lanes and streams.

Appearing on the scene are the M6 motorway, traffic lights and islands, car parks, traffic wardens, open cast mining at Bleak House, the Post Office Tower, satellite dishes, powerful street lighting, night clubs, pub meals, takeaways, fast foods, etc. etc. and I am sure the reader could add many more.

The photographs in the book highlight a lot of the changes, and I hope the reader will enjoy looking at them as much as I have enjoyed collecting them.

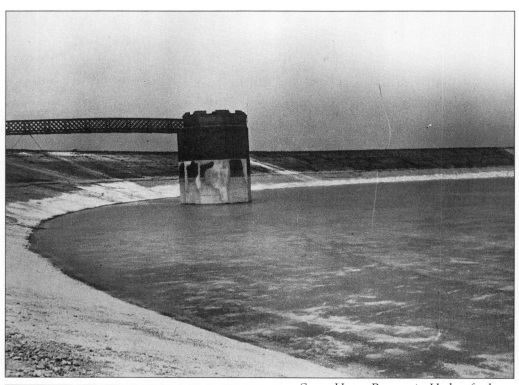

Scout House Reservoir, Hednesford, was built in the 1870s and closed in 1930; it is now the site of Hednesford Raceway. In 1887 a burst main began a chain reaction process which resulted in 43 million tonnes of water cascading down Hednesford Hills and washing away everything in its path. Miraculously no lives were lost but surrounding pits were flooded and sleepers from the village railway track were ripped out.

The water works at Huntington, looking towards Cannock; the man is standing on the A34.

One
Around the District

Sunnybank - but where? Answer on page 18.

Chadsmoor Playing Fields - and no safety precautions!

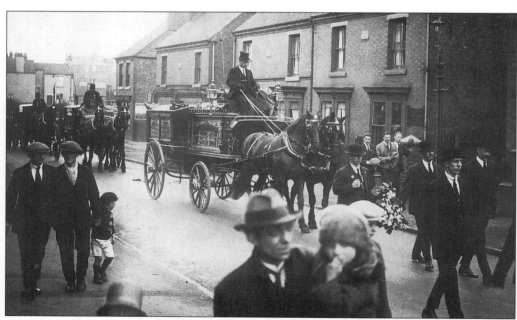

A funeral procession at Blackfords, Cannock, coming from what is now Sankey Road, towards the traffic islands.

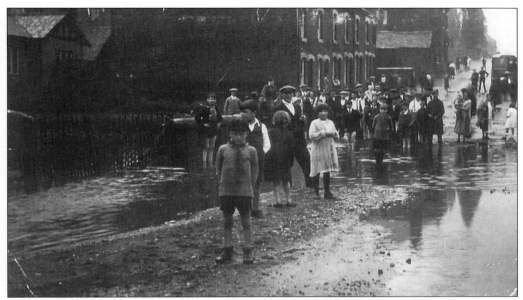

A cloudburst at Chadsmoor, June 1931, looking towards Hightown; among the crowd is Mr Hill.

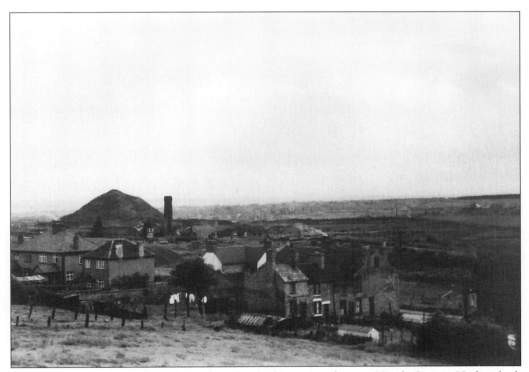

View taken by Charlie Parmenter from his bedroom window in Heath Street, Hednesford, overlooking the site of 1's, 2's and 4's Collieries, and showing the old Fox Row in the centre of the photograph.

The White Lion at Churchbridge, now demolished, in the triangle between the A5 and A34.

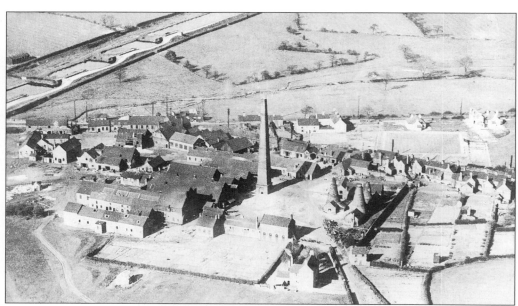

Churchbridge Works and canal locks, both no longer in existence. Some of the employees at the works were Messrs Rotchell, Parker, Bull and Groves, and Teddy Roden was the wheelwright.

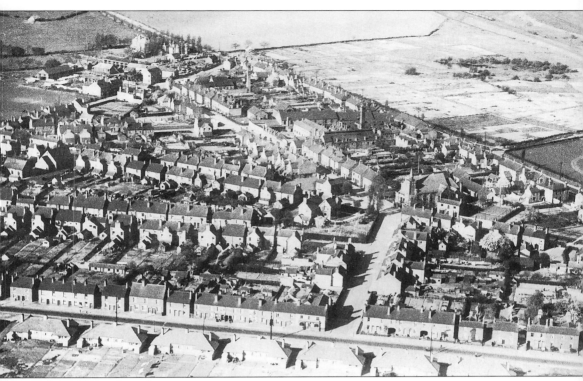

Bridgtown East, from the air.

The A5, Watling Street, at Bridgtown in 1907.

Looking down Walsall Road, Cannock, in 1886. This is now the busy junction of Walsall Road and Avon Road, complete with traffic lights. The church wall is on the left and a corner of D.W. Clarke's shop is on the right.

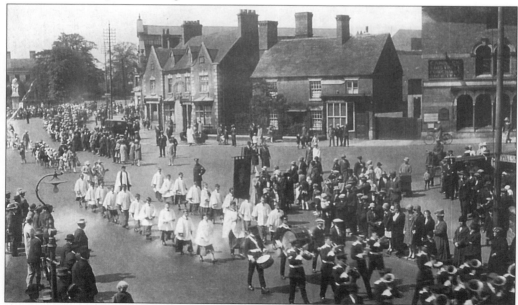

An unusual shot of Cannock town centre; clearly visible are The Crown Hotel and Wright's butchers shop, both now demolished. The board on the wall to the left of the lamp post reads 'Cannock & District Co-operative Society'.

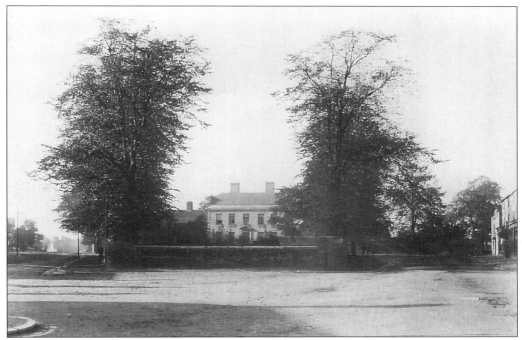

The Green and the bowling green, Cannock, in 1886, showing Stafford Road on the right and High Green on the left.

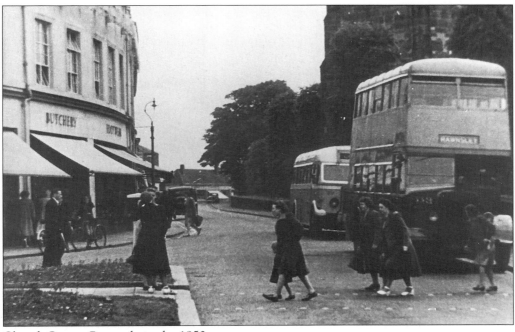

Church Street, Cannock, in the 1950s.

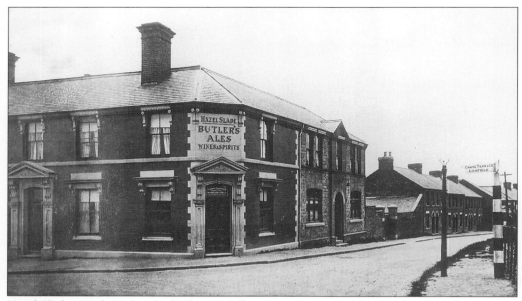

Hazel Slade Hotel, Hednesford. The row of houses no longer exists.

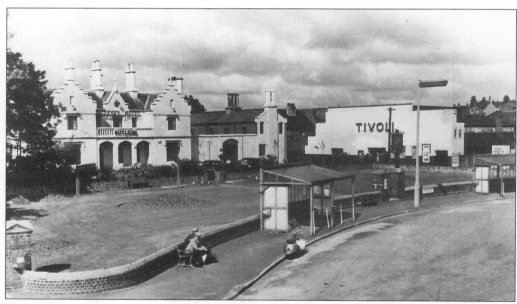

The Crescent and Gardens, Hednesford, showing that they were at that time used as the bus station. The Co-op replaced the Tivoli, and the Tivoli replaced the Electric Palace. This postcard was sent to Mr and Mrs Lee in Bournemouth in 1957 and the message on the back reads 'We are staying at the Anglesey Hotel (lovely bunch of digs), from Wilf.'

Bates's Corner, with a road to the left over the railway bridge, joining with the Rugeley Road, Hednesford. Bestmores Edge Tool Works was to the left on the opposite corner.

The Globe Inn, East Cannock Road, in the 1950s. Note the railway trucks to the left of the building.

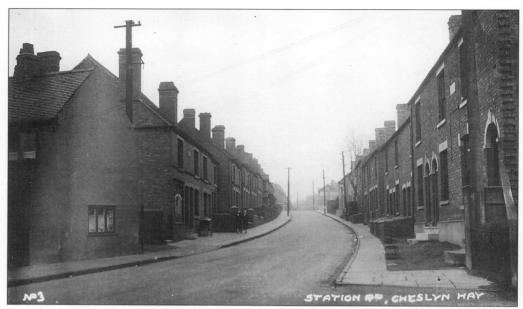

Station Road, Cheslyn Hay. The postcard was sent to Bourne End, Bucks, in 1944 and part of the message reads, 'What a lovely rest we're having! Not even the sirens here! I think we shall soon be rid of the bombs altogether, don't you?'

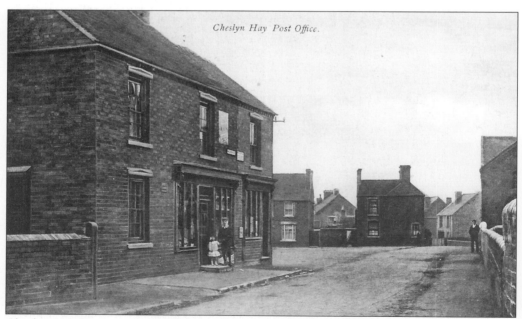

Cheslyn Hay Post Office.

Cheslyn Hay Post Office, posted in 1913 to Mrs Monkton in London from Ethel, stating that she got home in three and a half hours.

Answer: Sunnybank, the crossroads of Heath Gap Road, Common Lane and Crab Lane, Chadsmoor.

Two
Local People

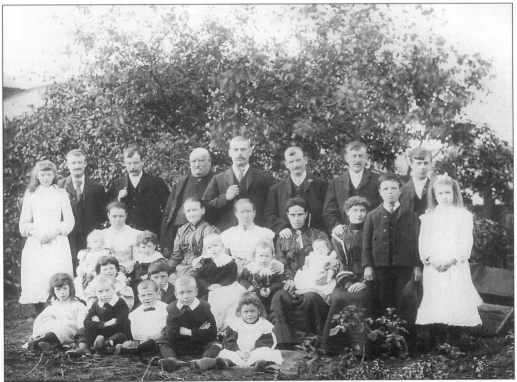

The Haywards and the Sandersons in the early 1900s. Back row, from left to right: Emma, Harry, Edward and Henry Hayward (Henry kept an off licence at Cannock Road, Hightown), George Sanderson, James, Jack and Victor Hayward. Middle row: Helen, Esther (née Dunning) Mary Ann, Lydia, Ginny, Jack Hayward (junior), Emma Sanderson, with their children and grandchildren.

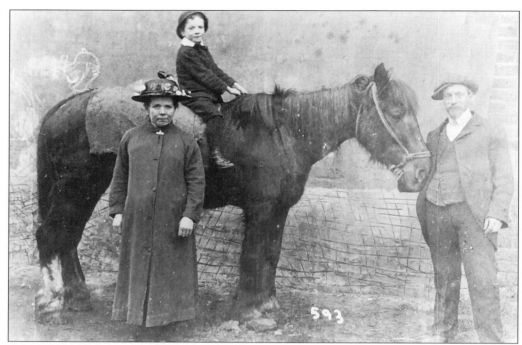

Taken in 1910-1911, the lad on the horse is Norman Martin with his mother and the owner of the horse, Mr Biddlestone.

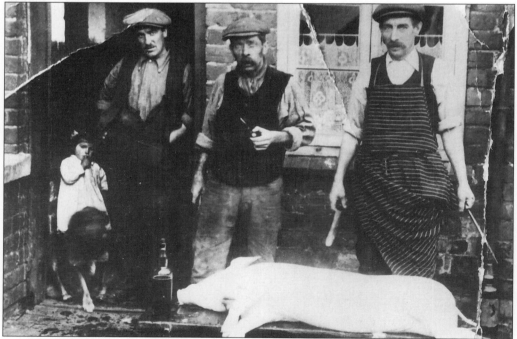

Ted Martin, the pig killer, with the Bishop brothers in the backyard of a house in Abbey Street, Hednesford. Note the bottle of beer on the bench. Pig killing was a common event in the life of the working class in 1910.

Dr John Kerr Butter, whose residence was on the site of the present police station.

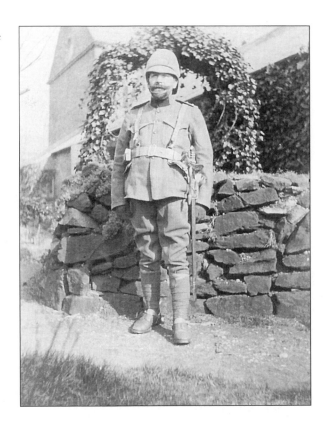

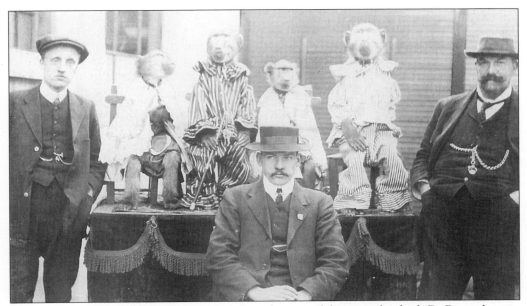

Dr Butter, far right, and Walter Bird, far left, with some of the animals which Dr Butter kept in his menagerie and which from time to time managed to escape, causing concern to the local inhabitants.

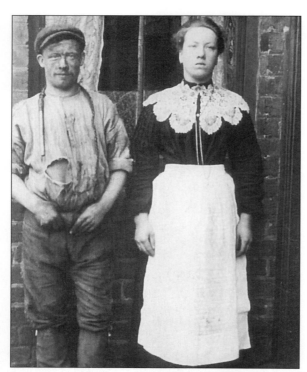

Charlie Jones and Mrs Cowley outside their home in the early 1900s.

From left to right: Mrs Jones, Joe Jones and Mrs Cowley. Note the imitated pose of the boy to the older man above, and the knife ready to cut the loaf of bread.

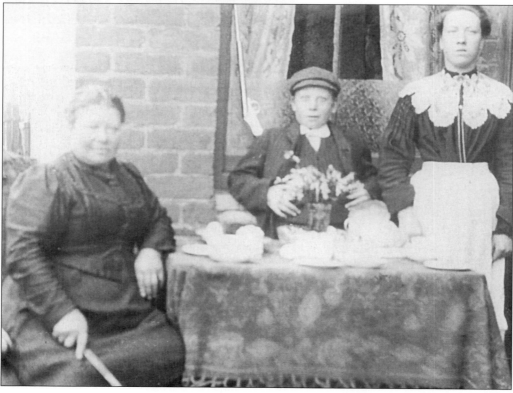

Edward Buckley of Heath Hayes, with the wooden chain he reputedly carved out of one piece of timber, now housed in a museum in Lichfield.

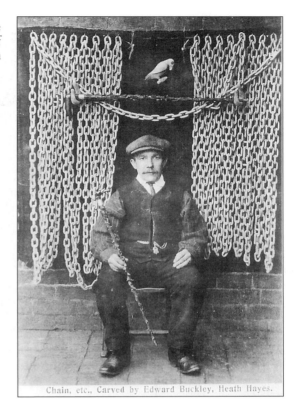

Chain, etc., Carved by Edward Buckley, Heath Hayes.

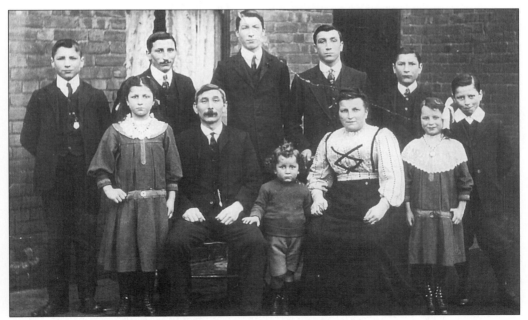

William Bott and family, all of whom emigrated to Australia.

The wedding reception at Hazel Slade of Bill Griffiths and Edna Brindley during the late 1940s. Pat Griffiths is holding the posy and members of the Brindley family, Mary Wilson, Austin Dudley and John Griffiths are all present.

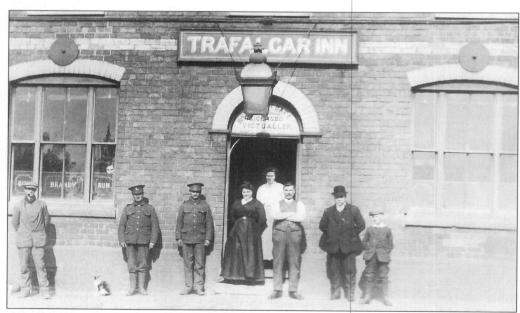

A well known landmark in the area is the Trafalgar Inn, (the 'Traff'), Littleworth Road, Hednesford. From left to right: -?-, -?-, Jack Thacker, Eliza, Isobel and Harry Bate, -?-, -?-. Mr and Mrs Bate were the licencees.

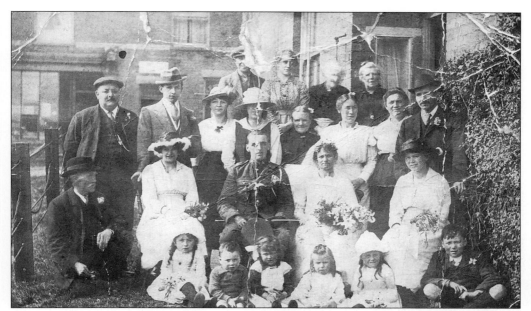

A wedding group in Station Road, Hednesford, with Mr Martin's barbers shop in the background, on a site opposite the present council bungalows. Fourth from the left in the group of children is Ada Owen, and Mrs Martin is on the far right in the back row.

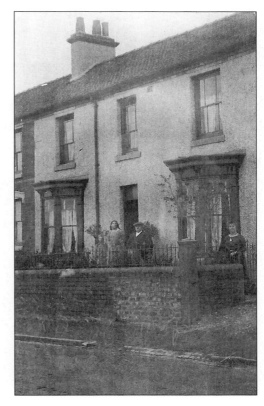

Lounden House, Littleworth Road, Hednesford, now the site of two new bungalows, opposite the old King and Queen Streets. From left to right: Ena and Isobel Bate, Charlie and Mary Harvey, (brother and sister).

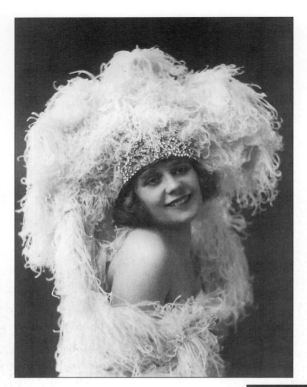

Gwladys Stanley Laidler became, in 1955, the most powerful woman in provincial British theatre, controlling the Alhambra and Princes Theatres in Bradford, the Leeds Theatre Royal and the Keighley Hippodrome.

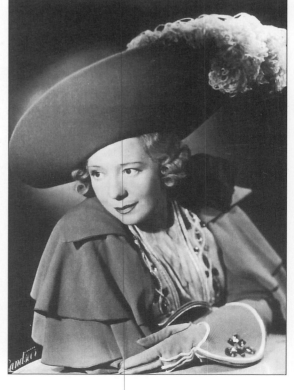

When she was interviewed in a Granada magazine programme for women she 'was terrified', but even so the press reported that, 'Wearing a fur coat and large feather hat she gave a delightful account of her experiences as one of this country's most famous principal boys.'

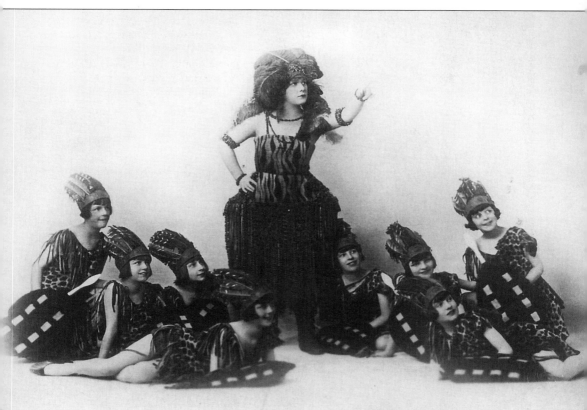

Gwladys Stanley Laidler Woodhead MBE was born Gwladys Florence Cotterill in Edgbaston, Birmingham, but at the age of two came to live in Hednesford. Her father and his brother both worked for the old firm of Bumsted and Chandler in Rugeley Road, Hednesford. She joined a concert party which entertained the troops stationed on Cannock Chase during the First World War. This led to employment with the *Premier Pierrots* who were the resident attraction at the Central Pier, Blackpool. She caught the attention of Francis Laidler, 'King of Pantomime', one of Britain's best known and respected men of the theatre, and soon became famous as a principal boy in pantomime. Although nineteen years younger, she became Francis Laidler's second wife in 1926. On his death in 1954, Gwladys became the owner of all his theatres. She was awarded the MBE for her work entertaining the troops with *The Bombshells*, writing, producing and appearing in the shows during the Second World War. She died on 17 July 1974.

The Hodgkins family in the front garden of their cottage in Cocksparrow Lane, Huntington.

The same location, but note the pit mound of Littleton Colliery in the background.

Three

Transport

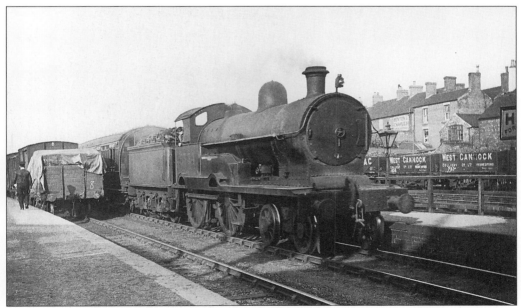

Hednesford station with the West Cannock Colliery trucks and the houses along Cannock Road - now demolished.

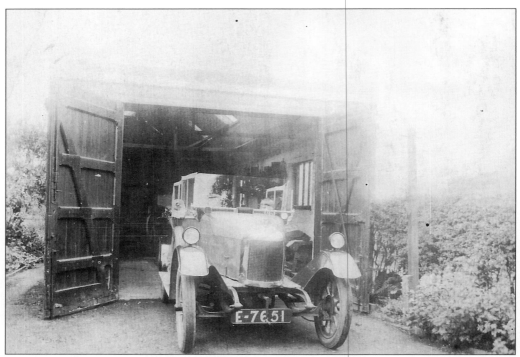

Vehicles owned by the Charlesworth family of 32 Anglesey Street, Hednesford, during the early years of this century. The pre-1926 Morris Oxford has no front wheel brakes.

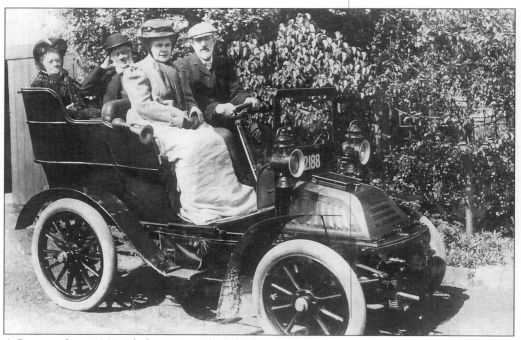

A Peugeot from 1902-3 belonging to the Charlesworth family.

A 1909 Humber, belonging to the
Charlesworth family.

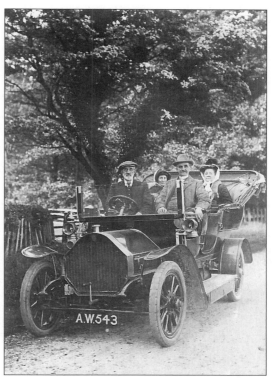

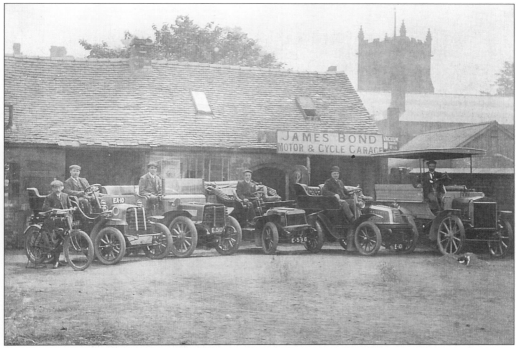

Bond's Garage in Wolverhampton Road, Cannock, showing an assortment of vehicles, with St
Luke's Church in the background.

The pillion passenger is Walter Bird, of Bird & Yates Garage, possibly in the early 1900s.

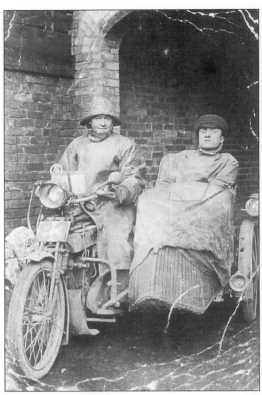

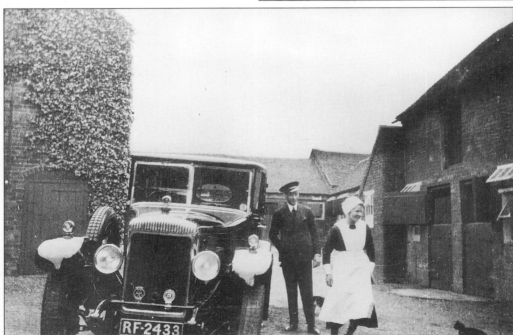

Tom Coulthwaite's training stables at Hazel Slade, Hednesford, with his car in the foreground, chauffeur Jim Macpherson and maid Miss Mary Boddis. (See page 65)

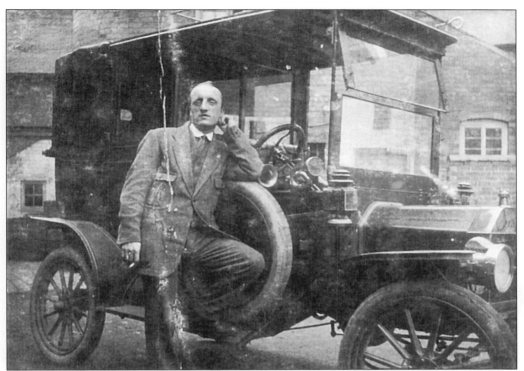

Walter Bird of Bird & Yates Garage.

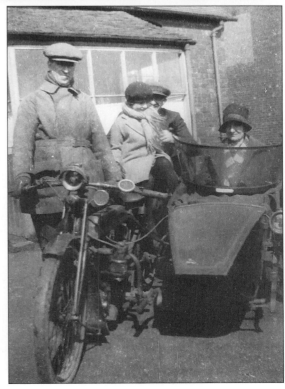

From left to right: Tom, Joan and May Bull with George Hodgkiss, at the rear of a bungalow in Mount Side Street, Hednesford, c. 1926.

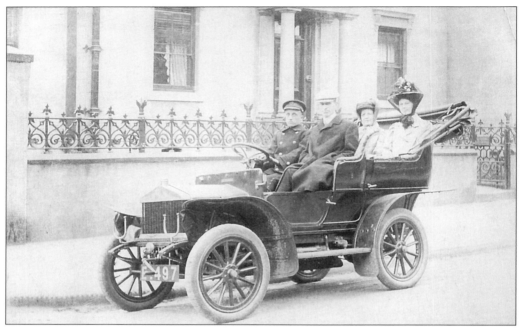

Outside Dr Butter's house in Wolverhampton Road, Cannock, with Walter Bird, the chauffeur in the driving seat.

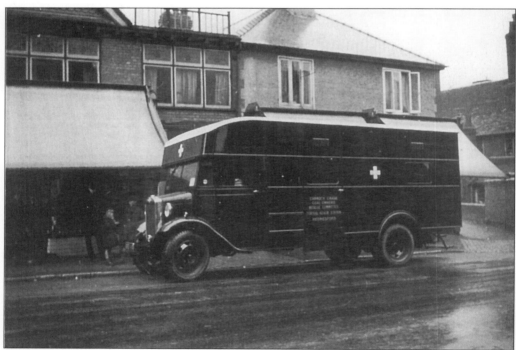

Cannock Chase Coal Owners Rescue Committee ambulance, parked in Walsall Road, Cannock.

Four
Julia Maud Gilpin's Album

Julia Maud was born in 1857. Most of the following photographs have been extracted from her private family album and were taken in 1886.

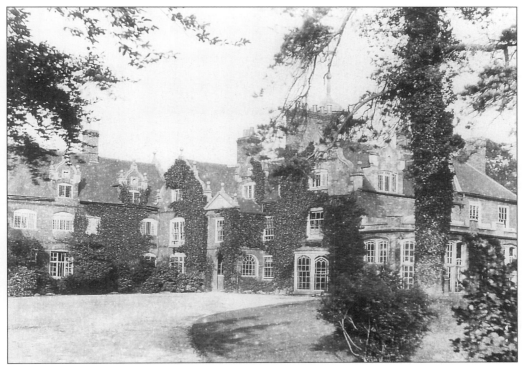

Little Wyrley Hall, home of the Wallace family.

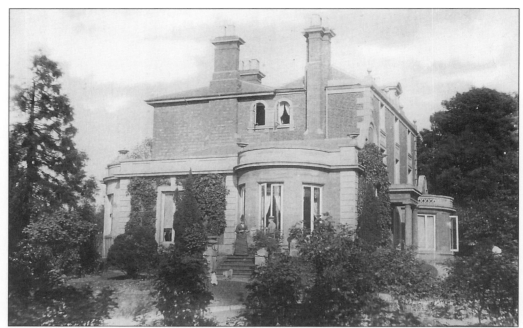

Longford House, home of the Gilpin family. William Gilpin Sen. & Co. (Tools) Ltd, was established in 1763 at Wedges Mills, for the manufacture of sharp bladed tools. Early in the nineteenth century they moved to Churchbridge at the junction of the A5 and A34. The works have recently been demolished, but part of the boundary wall still stands, with some of the land now lying derelict. The company was a major employer in the area, drawing their workforce from all over the Cannock district, and the first industry to become established there apart from small scale mining.

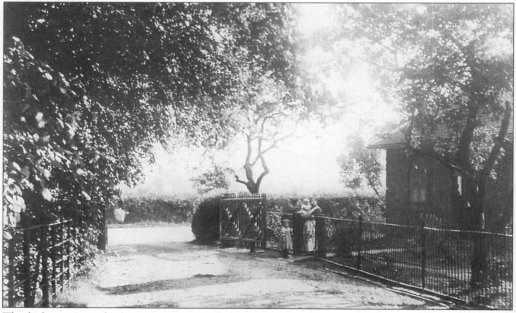

The lodge to Longford House, entering from the A5.

Longford crossroads in 1886, looking towards the Four Crosses public house, at the junction of the Cannock and Wolverhampton Roads.

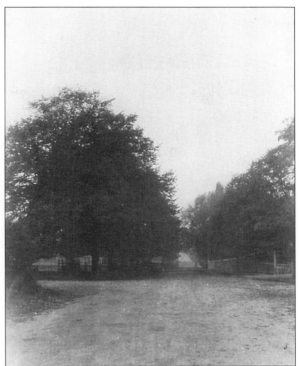

The same scene at a later date, with the Black Cock pub on the corner. Note the addition of telegraph poles.

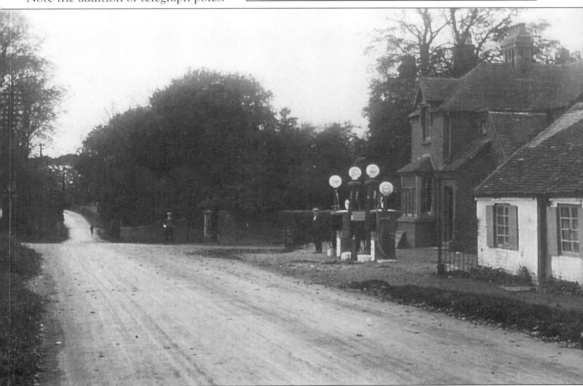

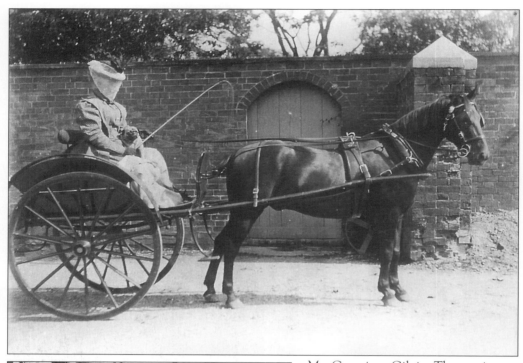

Mrs Georgiana Gilpin. The caption to this photograph is written in the album as 'Mother driving John and Migs'.

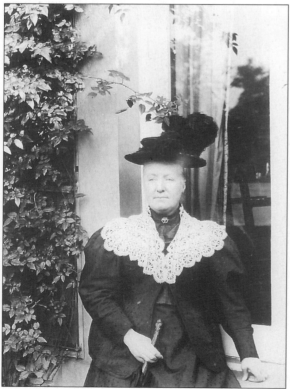

Mrs Georgiana Gilpin proudly displaying her beautiful lace collar.

Mr Bernard and Mrs Georgiana
Gilpin.

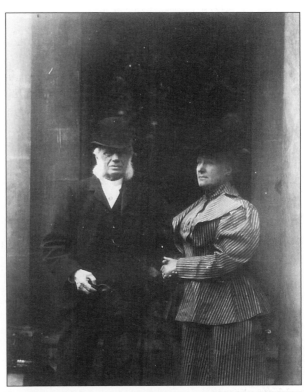

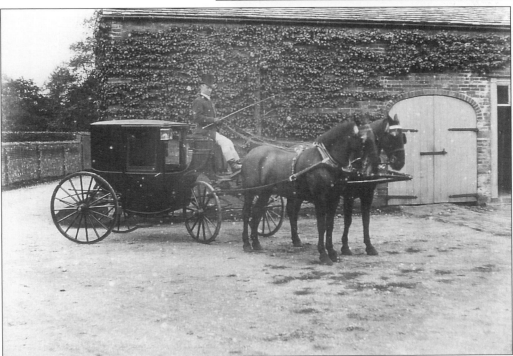

The Gilpin carriage driven by Rangecroft.

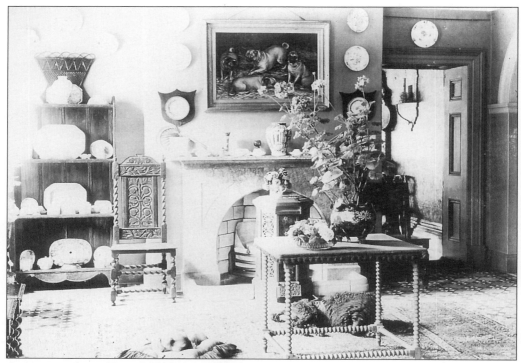

An interior shot of Longford House. Note the painting of the dogs over the fireplace and those lying on the floor. The family kept a number of dogs, with names such as *Kaiser*, *Poodle*, *Middy*, *Tartar*, *Snip*, *Migs*, *Wee-Wee*, *Jabez*, *Tatler*, *Shrimp*, *Tommy*, *Joco*, *Milo* and *Wuppy*.

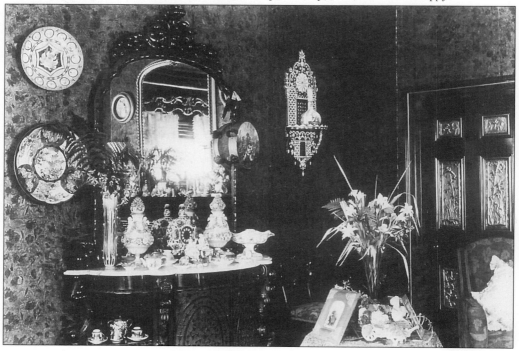

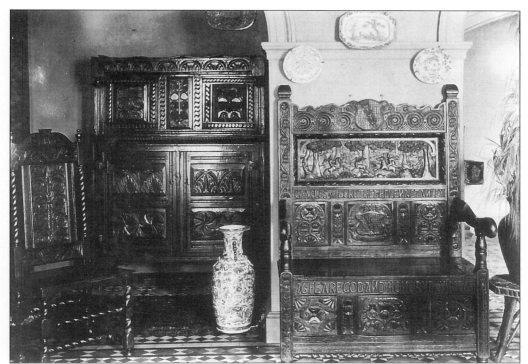

Above: Carved oak furniture. Written on the back of the seat are the names 'CHARLES and DOROTHEA HELENA STANLEY" and on the front, the inscription '76 FEARE GOD AND HONOR YE KYNGE 65'.

Right: A dresser with an impressive display of china.

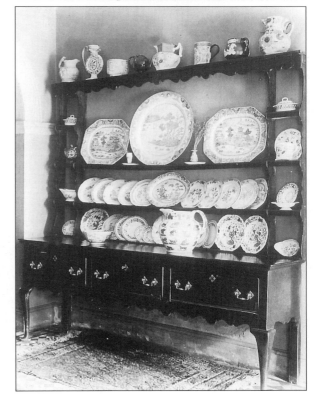

Opposite: Another room in Longford House.

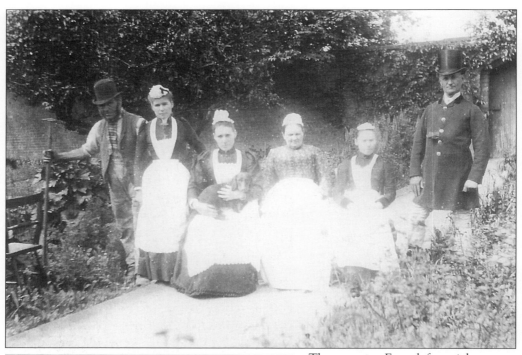

The servants. From left to right:
Plant, -?-, Alice, Mrs Adams, Mary
and Rangecroft.

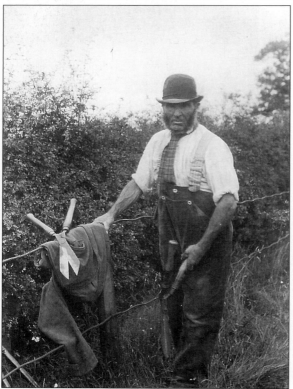

As written by Julia, 'Plant "A Son of
Toil"'.

Sarah, the governess.

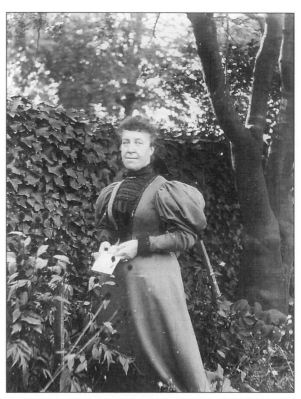

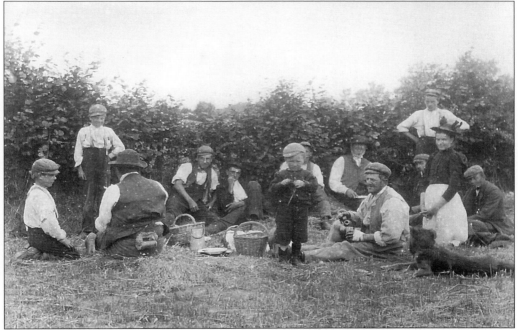

Tea break at harvest time with John James, farm hands and their families. It was often the children's job to take meals to their father's workplace, whether in a factory or the open fields.

Violet Holden.

From left to right: Bernard Gilpin (junior), Kitty Vernon, Staveley Hill, Mabel Simpson and Mary Vernon.

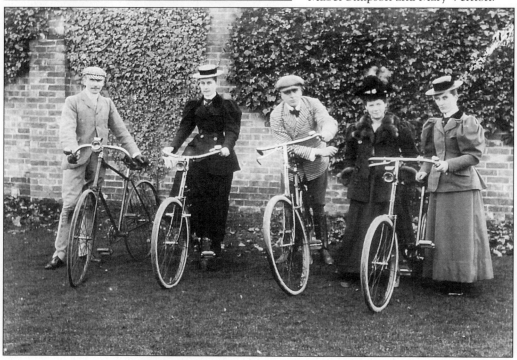

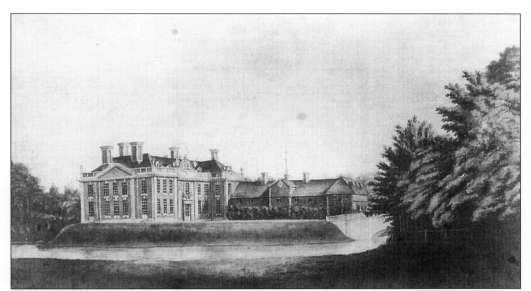

The Hall - Hilton Park as it was in 1790, from an impression 'Given to G.J. by Squire Vernon Sep 20 1915'. 'G.J.' is possibly G.J. Astbury. The two storey L-shaped building, as shown, was built in the early seventeenth century by the Vernon family, and an upper storey was added in 1829. It is now the group head office of Tarmac plc.

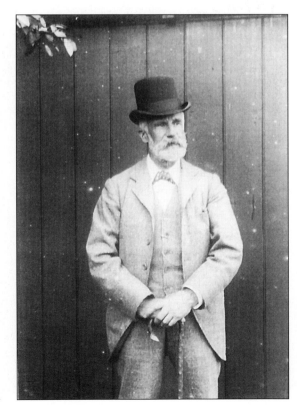

Squire Vernon of Hilton Park.

Nellie. (See below)

Brodie. Both Nellie and Brodie were
friends of the Gilpin family. Note the
hand span waists.

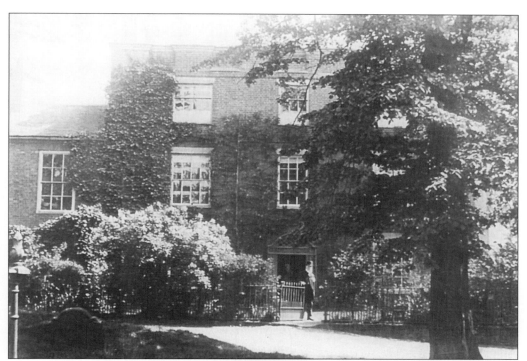

Cromwell House, the residence of Dr Cromwell Blackford, in Mill Street, Cannock, viewed from St Luke's churchyard. Note one of the old tombstones in the bottom left corner. This building is now the home of the Ancient Order of Foresters.

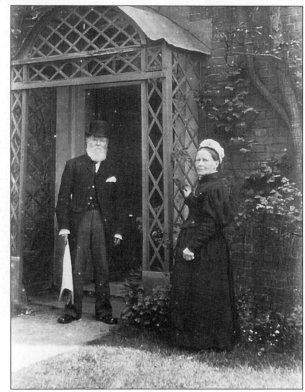

Dr Cromwell Blackford and Miss Blackford outside their residence.

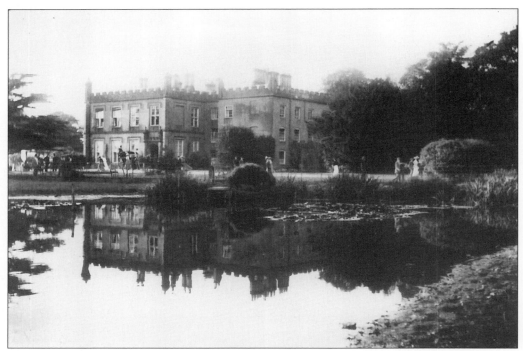

Hatherton Hall in the early 1900s, showing an unusual amount of activity. This was the home of the Walhouse family who married into the Littleton family and became the Lords Hatherton.

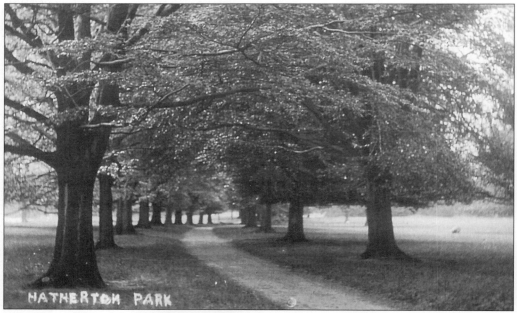

The old beech-lined drive down to the Hall. The trees were cut down in the 1960s.

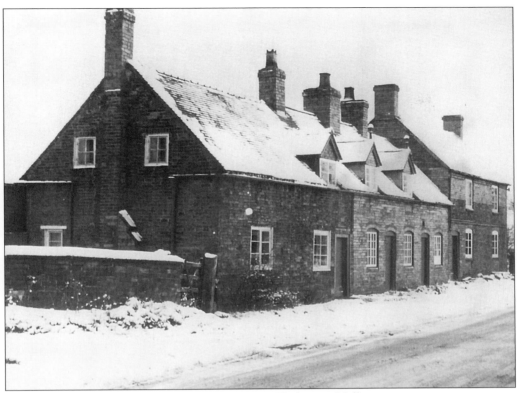

Bowling Green cottages, opposite the entrance to Hatherton Hall.

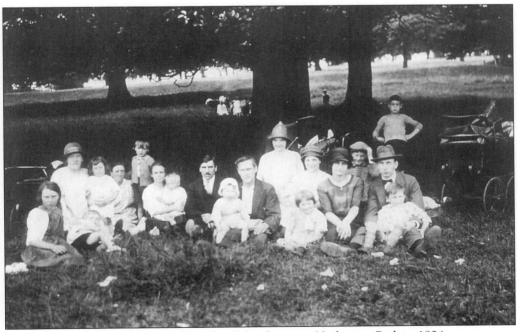

The Primitive Methodists annual Sunday School treat at Hatherton Park·in 1924.

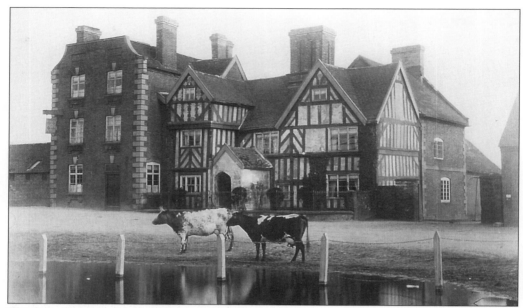

The Four Crosses public house in 1886, with what is now the A5 running between the building and the pond.

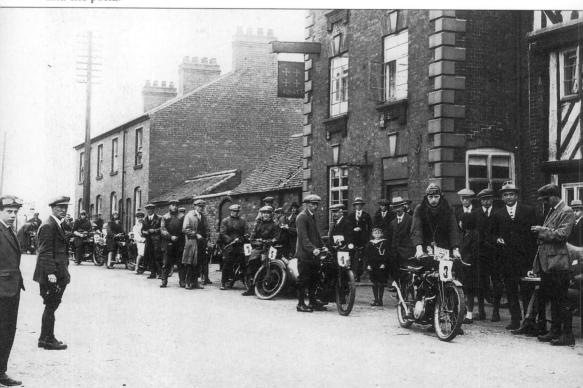

Assembly of a motor cycle run outside the Four Crosses public house, some time after the First World War.

St Saviour's Church at Hatherton in 1886, before the addition of the extra accommodation on the left side of the building.

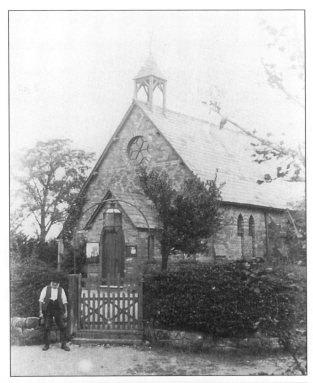

The interior of St Saviour's Church at the same date; note the impressive oil lamps.

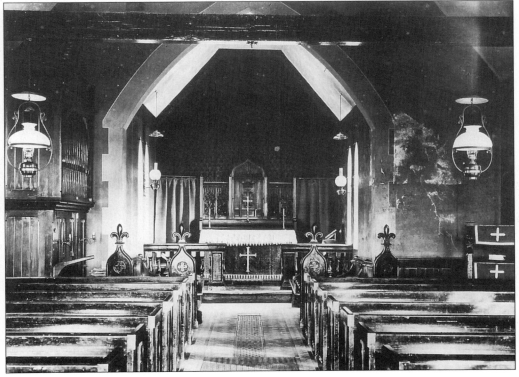

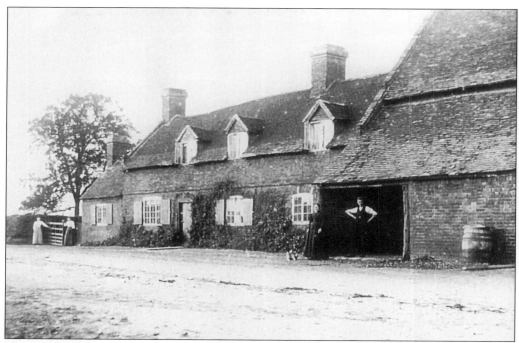

The Whitehouse family's residence and forge at Four Crosses, with the Whitehouse family in the doorway and at the gate. This is now the site of the filling station, but the barn at the rear is still standing.

The well at Hatherton. From left to right: Frank, Will and George Pilsbury.

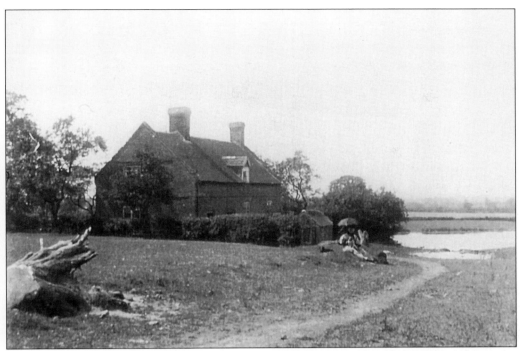

Two cottages at Hatherton, which were situated in a field to the rear of Bowers Farm and below where the well used to be.

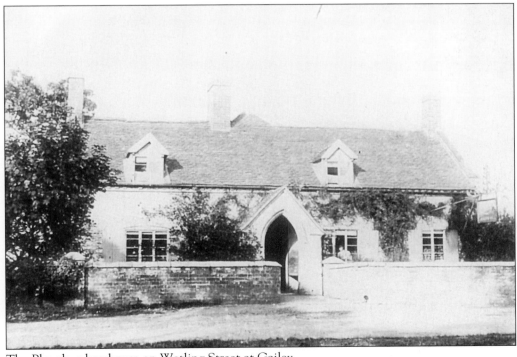

The Plough, a beerhouse on Watling Street at Gailey.

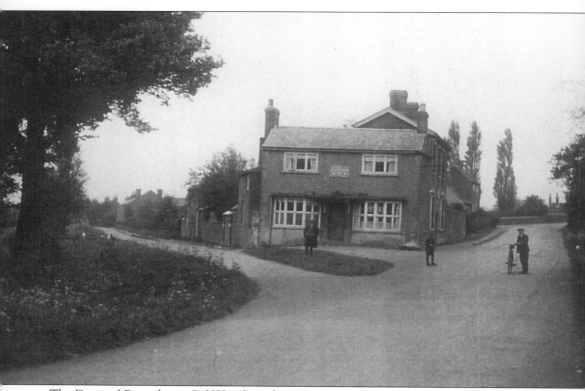

The Dog and Partridge at Calf Heath in the 1930s.

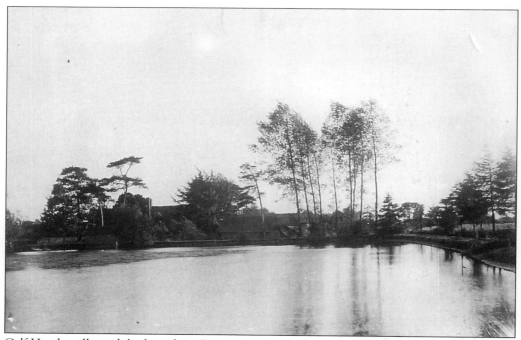

Calf Heath mill pond, looking from Four Crosses to Calf Heath.

Bridge at Calf Heath, opposite the old post office.

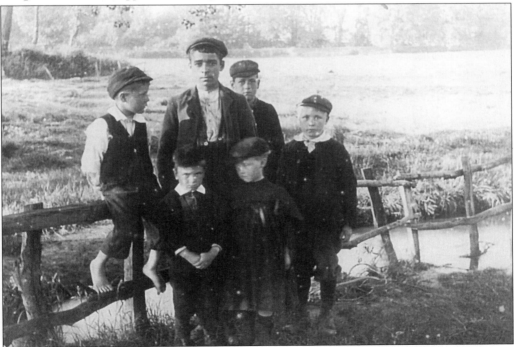

A group of boys at Wedges Mills. Note the bare feet and ripped shirt of the boy on the fence, and one of the other boys wearing a dress, which was quite usual at that time.

Cutting corn at Royals Farm, Hatherton.

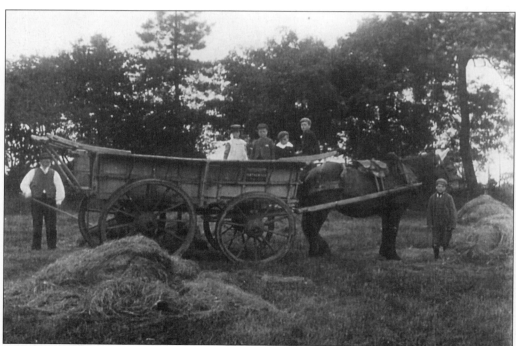

A Staffordshire farm cart during hay making on John James' farm at Hatherton. John James is on the far left.

Five

Sport and Leisure

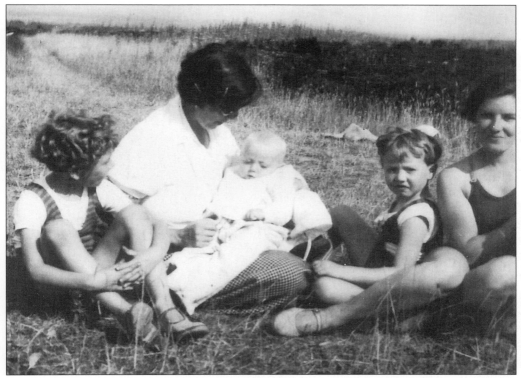

On the Chase during the summer of 1937. From left to right: Alex White, Mrs White, baby Mary White, Gordon White and Ivy Errington.

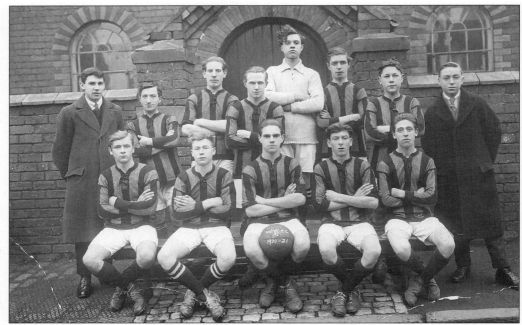

Glover Street, Wimblebury Chapel football team, participants in the Cannock Church and Chapel League 1920-1921. Their strip was black and tan, and reversible black and white. T. Weston was the goalkeeper. Back row, from left to right: T. Ward, H. Green. Middle row: J. Clark, L. Farr, A. Jones, C. Nixon, F. Dale. Seated: J. Nicholls, B. Mason, W. Anslow, W. Thacker and H. Bailey.

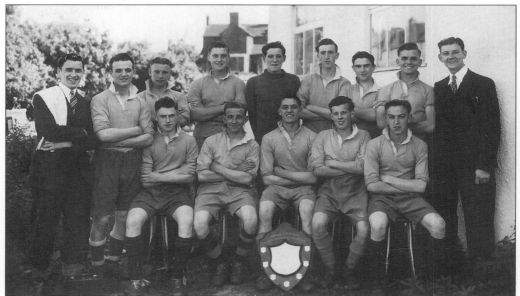

Winners of the Cannock and District Youth Sports Committee District League Challenge Shield. Back row, from left to right: A. Poole, (trainer) B. Jones, K. Lyons, D. Littler, R. Brindley, A. Lewis, K. Blastock, N. Jones, H. Edwards. Seated: ? Tazzer, D. Lane, A. Miles (captain) G. Tilsley, L. Burton.

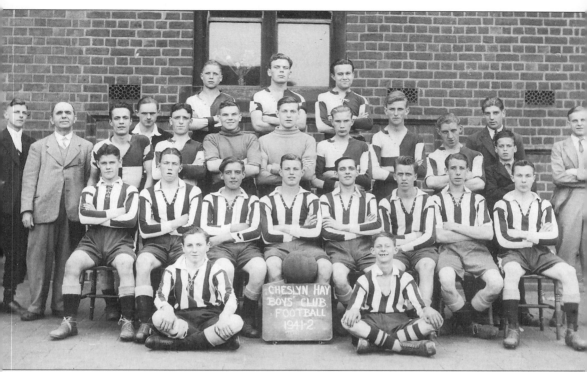

Cheslyn Hay Boys Club football team, 1941-2.

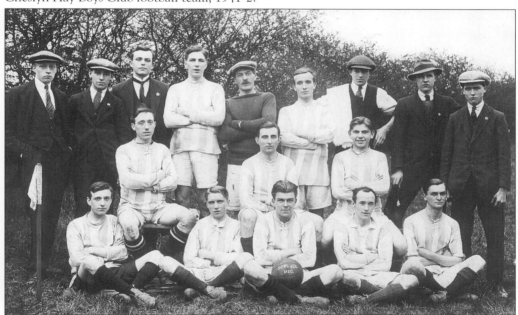

St Paul's Football Club, Bridgtown, 1920. Back row, from left to right: Sam Birch, Albert Jackson, -?-, Harry Till, Bill Till, Vic Morris, Wink Elsmore, Tom Cotton, Arnold Sambrooks. Second row: Roland Greenway, Arthur King, Edgar Machin. Front row: Christopher Greenway, -?-, Reg Deakin, ? Taylor, Reg Hughes.

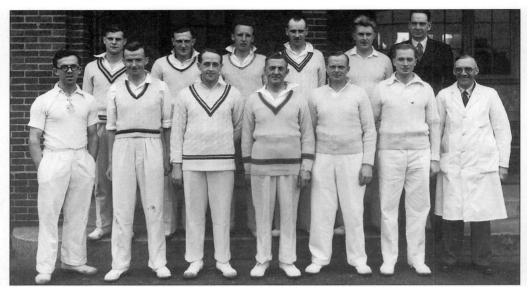

Cannock Park Pavilion Cricket Team. Back row, from left to right: Peter Croft, Ron Harvey, Joe Carlton, Chris Hatton, Harold Cowern, Alec Alcock. Front row: Mick Bowers, John Haynes, Ron Whitehouse, Cecil Hawkyard, Jack Richards, Roland Whittington, Charlie Nicholls.

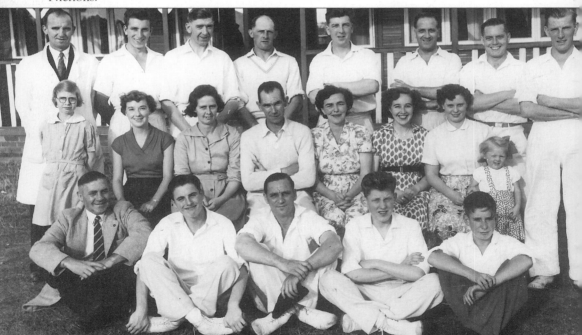

East Cannock Colliery Cricket Team, 1953/4. Back row, from left to right: umpire, Bill Yapp, Clive ?, Ted Harvey, Jim Oakley, Bill Bentley, Stan Rowe, Cliff Schofield, George Bentley. Second row: ? Harvey, Dorothy Bentley, Mrs Harvey, Bill Garbut, Mrs Sturgess, Beryl Schofield, Mildred Bentley, Sandra Bentley. Front row: Alf Edwards, Alan Pugh, Alf Massey, John Smith, -?-.

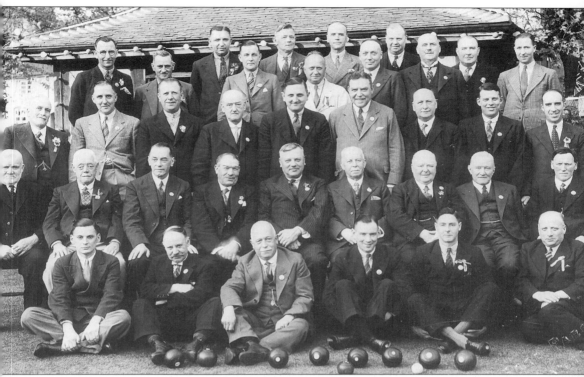

Bowling Green, Cannock. Among the assembly are Reuben Dudley, Bos Spencer, Herbert Spencer and William Beesley.

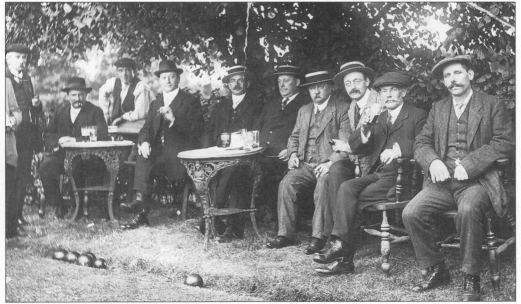

Anglesey Hotel Bowling Club, Hednesford, in the 1920s. From left to right: Mr Mellor, Mr Edgar Wright, -?-, Mr Underwood, Mr Keen, Mr John Cotterill, -?-, Mr George Watwood, Mr Briggs, -?-.

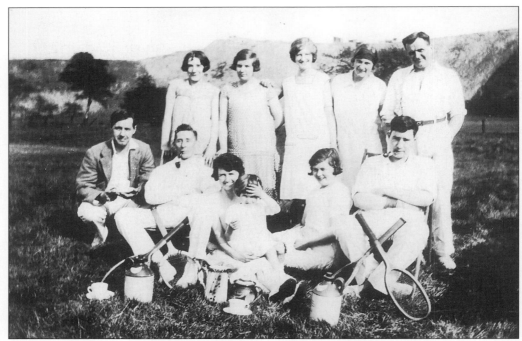

The tennis club of St John's Church, Station Road, Hednesford. The two courts were situated on land between Cannock Road Hightown, and East Cannock Road, with East Cannock pit mound in the background. Back row, from left to right: -?-, Rhoda Bradbury, Marjorie Cotterill, Doris Elliot (née Merrit), Mr Elliot. Front row: Mr Parker (teacher), Tom Hartshorne, Mrs Hartshorne, Mary Elliot and Cora Croft (child), Herbert Porter.

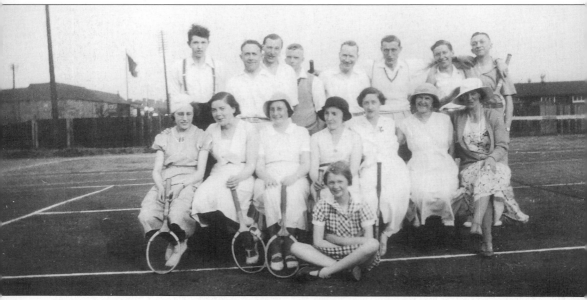

Bridgtown tennis club. Among those in the group are Percy Dudley and John Richards in the back row and Peggy Richards and Nellie Dudley in the front. Unfortunately the other names are unknown.

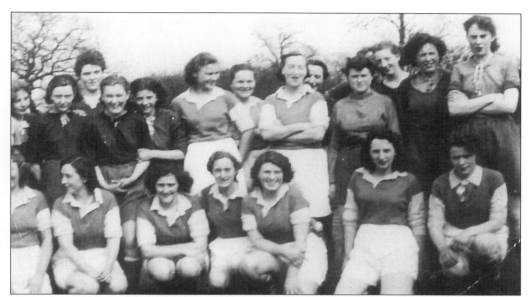

The married and single women's football team from Wedges Mills, on Easter Tuesday, 15 April 1952. In the team were M. Bates, S. Lewis, R. Pee, T. Downton, G. Dawson, M. Pee, B. Pee, D. Hodgkiss, J. Dawson, D. Partington, V. Clawley, M. Craddock, G. Taylor, R. Brindley, A. Sargent, Moore, M. Downton and J. Amphlett.

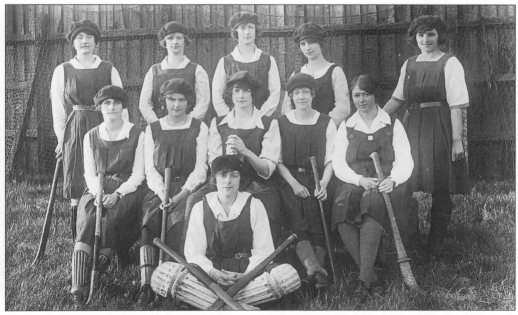

Cannock Ladies' Hockey Club, 1921/22. Among the group are Miss Hunt, Mrs Fred Linford, Miss E. Birch and Agnes St Leger.

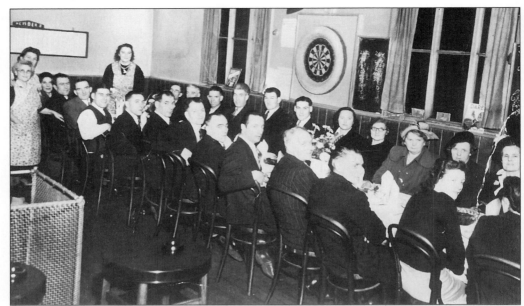

Ye Olde Birds domino team supper in 1949. Back row, from left to right: Mrs Holland, Sam Dunkley, Jack Molloy, Arthur Wilkes, Tom Middleton, Harry Cartwright, Vic Cartwright, Mrs Brice, Mrs Talbot, Mrs Allen, Mrs Cotterell, Mrs Molloy. Front row: Sally Dunkley, Nell Winfindale, Mrs Lightfoot, Jack Lightfoot, Bill Winfindale, Harry Cartwright, Fred Nicholls, Bill Wootton, Arthur Brice, Joe Talbot, Bert Langley, Harry Allen, Ted Cotterell, Hilda Cartwright.

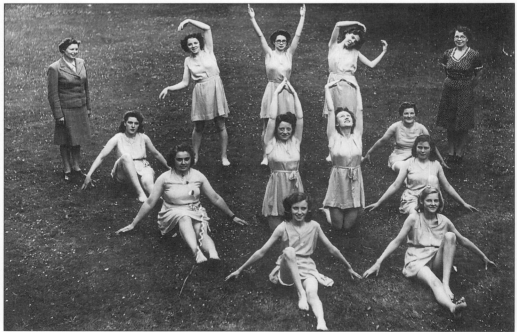

St Mary's RC Youth Club keep fit display, July 1945. On the left is Mrs Crumpton-Smith, from the Central Council for Physical Recreation.

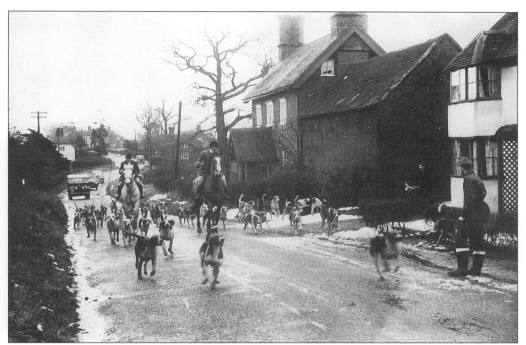

The Hunt at Longdon in the early 1960s.

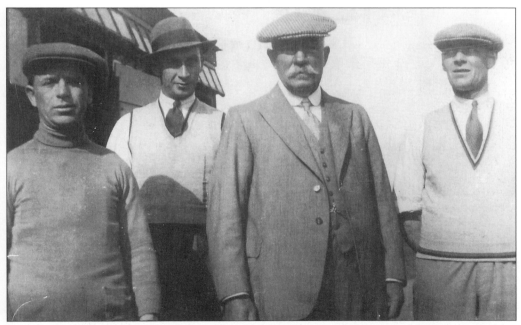

From left to right: Albert Brace, Jim Macpherson, Tom Coulthwaite and Dick Rogers. Tom Coulthwaite had the racing stables at Hazel Slade and became one of the best known trainers in the country by producing three Grand National winners: *Eremon* in 1907, *Jenkinstown* in 1910 and *Grakle* in 1931.

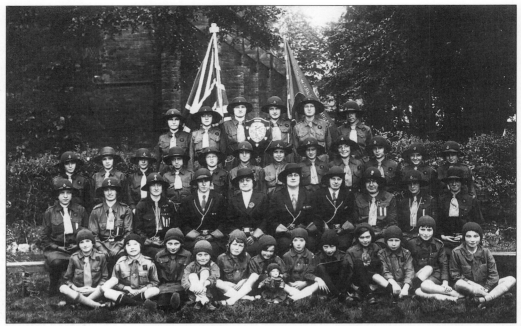

The Girl Guide Company of St Mark's Church, Great Wyrley including: Captain Beebee, Doreen Masters and Company leader Ethel Titley.

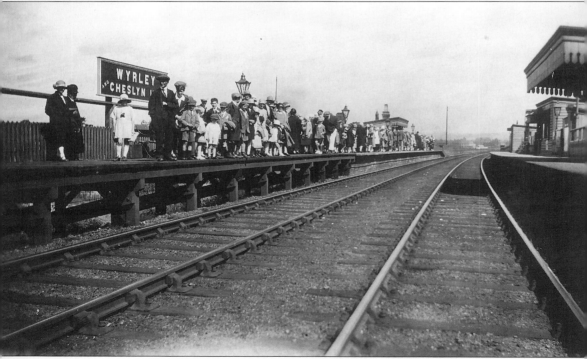

Mr Carter's trip to Llandudno, July 1928, assembled at Wyrley and Cheslyn Hay railway station.

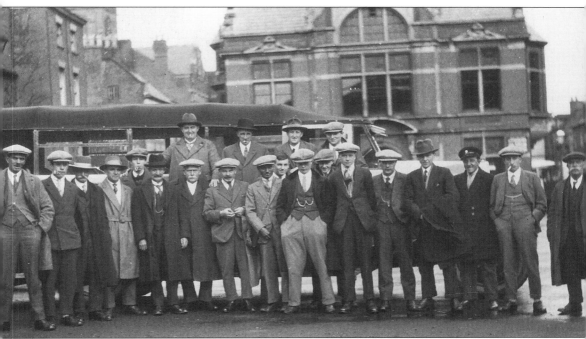

An outing for employees of Green & Bird Ltd, builders and contractors, West Hill, Hednesford. Front row, from left to right: the preacher from Bradbury Lane, -?-, Mr Green (senior), Edmund Green, -?-, Jim Pope, -?-, Charlie Bird, Anwarul Hassan, Bert Hindley, -?-, Mr Langston, Benny Westwood, -?-, -?-, Driver, Bill Stringer, Mr Stringer (senior). Back row: Harold Tatler, Les White, George Farr (senior), Cyril Kendrick.

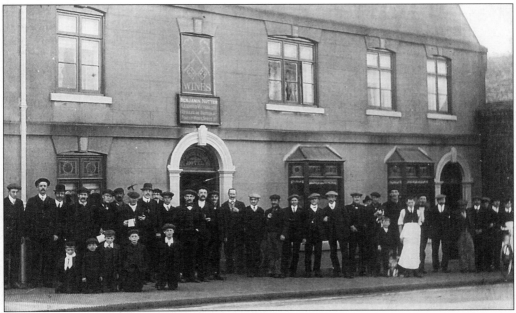

Cross Keys public house, Hill Street, Hednesford, in the early 1900s. The licencee at the time was Benjamin Nutter.

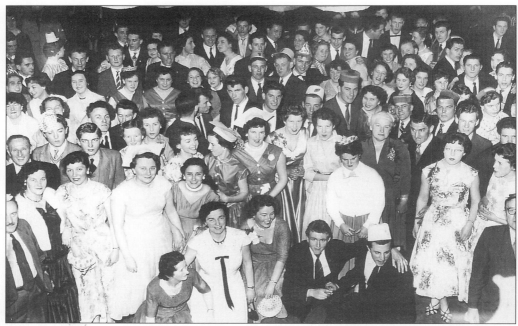

The annual dance of the firm of Town Mills, Cannock, attended by employees and local people alike, at the Civic Ballroom (now Aquarius) Hednesford in 1956. Among the crowd are Joyce and Janet Bevington, Daphne, Margaret, June and Mrs James, and local beauty queen Sylvia Evans.

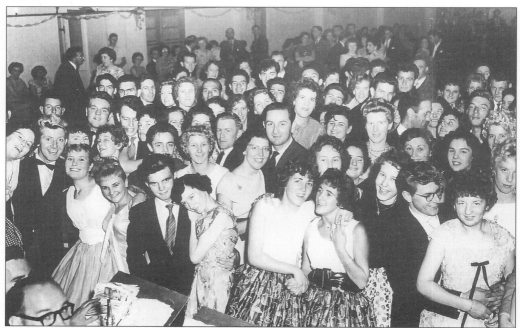

The annual dance in the following year - a highlight on the social calendar - was organised by Daphne James, a secretary at Town Mills, seen to the right of the photograph. Her sister June is in the centre of the crowd. Many local people will recognise themselves.

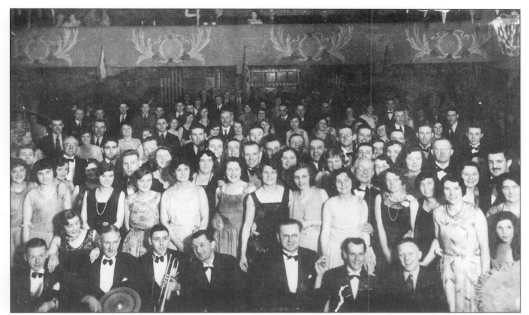

The last Police Ball to be held at the Electric Palace in March 1931, before it became the Tivoli Cinema. Most of the local trades people and shopkeepers in Hednesford are present, and amongst them are Norman Lavender, Gladys Haynes, Ada Bagley, Cath Underwood, Alf Edwards, Ethel Harvey, Mrs Forrester, Len Spruce, John Hardman, Bill Tranter, Fred Broom, Vi Tennant, Felix Harper, George Stacey, Mrs Homer, Les Lockley and Mrs Haywood.

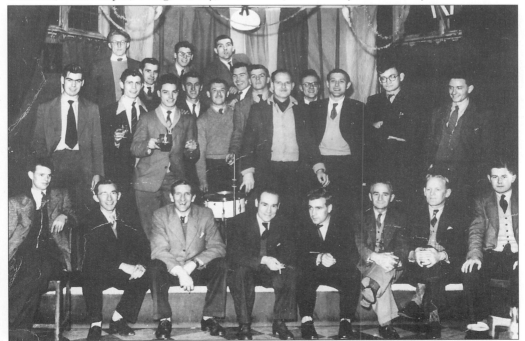

A group of young men from Cannock Mining College at a smoking concert. Horace Spruce is standing to the left of the drum.

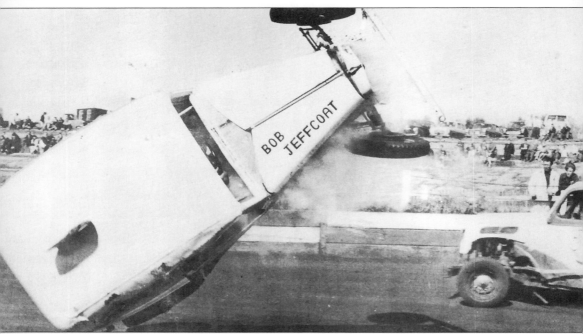

During a stock car race at Hednesford Hills Raceway in the early 1960s, this driver decided that the only way to get noticed was to do something spectacular and at this split second the whole of the car was in mid-air. It was claimed that the quarter mile track was the fastest and finest anywhere in Europe and it was the dream child of Mr Bill Morris, himself a prominent driver of stock cars. From a disused water reservoir it was developed into a stock car racing circuit in 1954 but due to the lack of acceptable standards for spectators it closed after a couple of years. Bill Morris took over in 1962 and started to develop the stadium to the standard he thought was needed.

Six

Events

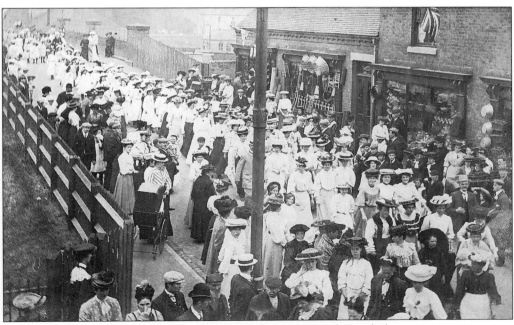

The Station Bridge, Hednesford; heading towards Green Heath Road, the procession turns into Station Road. The occasion in the very early 1900s is unknown, but as there appears to be only one gentleman (behind the lamp post) actually in the procession, it could be a 'Votes for Women' show of force. Note the flag in the upstairs window and the array of items for sale in Hardman's shop.

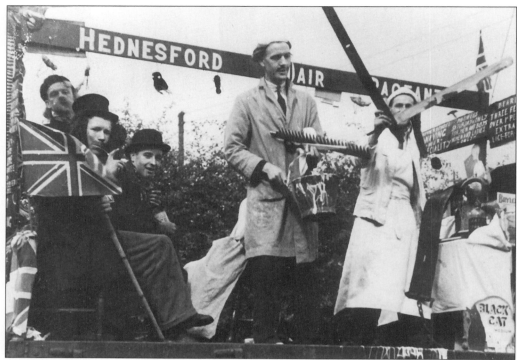

A float in Hednesford Pageant in the mid 1930s, which was organised to raise money for local hospitals. The scene is a barbers shop and seated on the left is Dennis Farr.

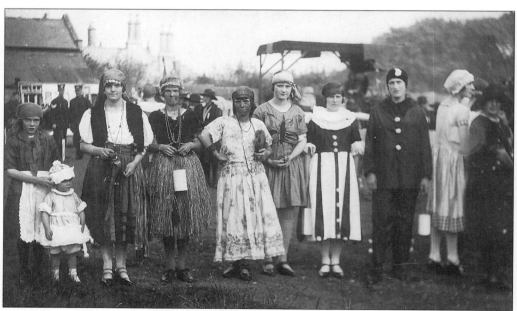

A fancy dress group in the pageant in Anglesey Street, Hednesford, with the Anglesey Hotel in the background; sixth from the left is Doris Norton and eighth is Florence Hassall.

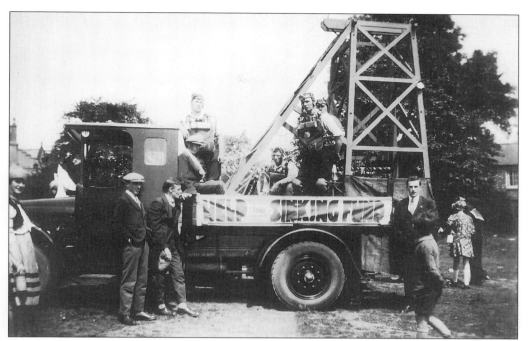

Another float in the same pageant.

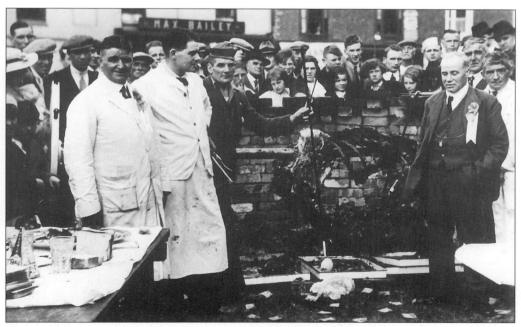

The ox roast in Anglesey Crescent, Hednesford. The butcher in the centre was named Roberts and Johnny James, a Labour councillor, is on the extreme right.

A group in a Scout's concert party; sitting on the far right is Albert Yates.

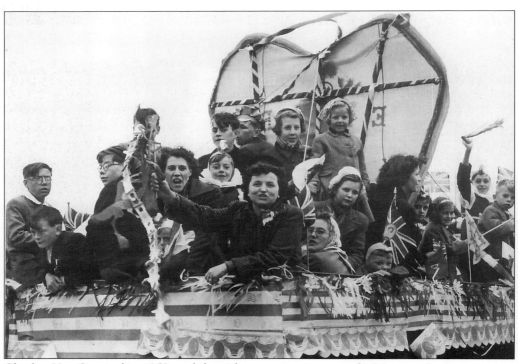

Cheslyn Hay Carnival in 1952, and the girl on top wearing a scarf is Margaret James.

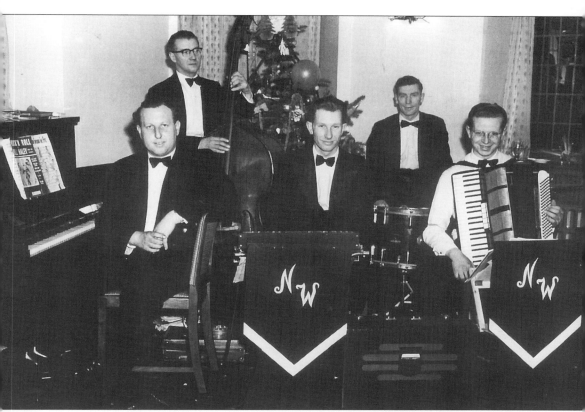

Norman Wright and his Band in the 1950s. Back row, from left to right: David James, -?-. Front row: Norman Wright, Duncan Brough and Percy Lees.

A concert at Great Wyrley School in 1945. From left to right: Betty Newman, Mary Stanley, Daphne James, Doreen Bowen, Nellie Peach, Barbara Horton, Mary Round, Pat Horobin.

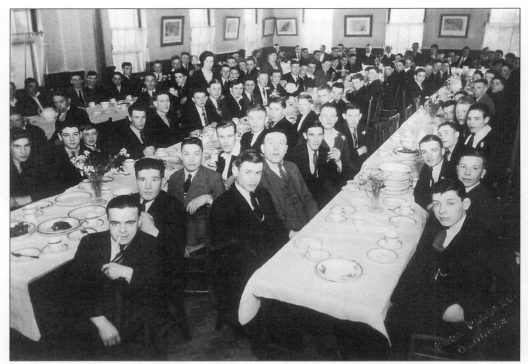

Pupils at Cannock Mining College in the 1930s. Bert Hibbs is sitting on the top table second from the right in the back row.

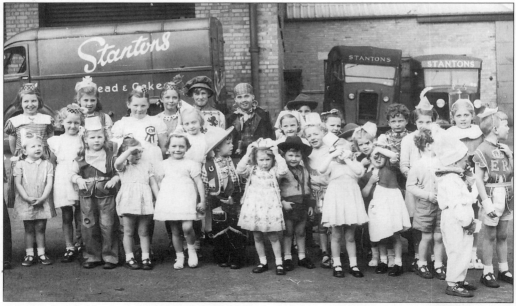

A party for children in the area of Green Heath Road, at Stanton's Bakery, to celebrate the coronation of Queen Elizabeth II. Among the children are Anna and Christopher Gellion, Beverley Hindley and Miranda Gething. Stanton's Bakery was one of the biggest local bakeries, situated in Western Road, Hednesford, but is now demolished.

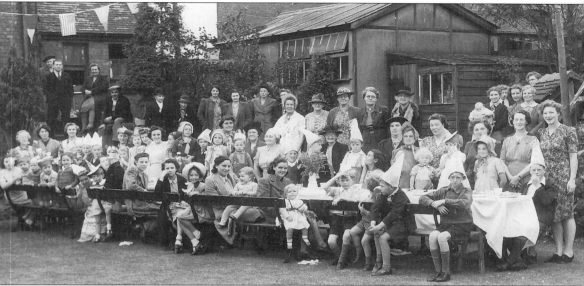

VJ Day celebrations at Richmond Cottage, West Hill, Hednesford. Among those present are Mrs Moreton, Betty Moreton, Nancy Hindley, Ida Gellion, Tom Fowler and Margaret West.

Celebrating VE Day on 8 May 1945 in Florence Street, Hednesford. Known names are: Liza Dunning, Mrs Shaw, Mrs Francis Molloy and Pauline, Len Stanton, Peter Molloy, Mrs Molloy, Pat Molloy, Lance Shemwell, Eadie Rogers, Molly Molloy, Gordon Molloy, Bernard Turner, Ken Shaw, Mrs Waterworth, Alan Molloy, Len Thomas, Ted Matthews, Digger Powell, Gordon Bromley, Nurse Phillips from Green Heath Road, Mary Martin, Ron Loverock, Mrs Phillips-Cox, Eadie Beardsmore, Mrs George Evans, Mrs Saunders, Mrs Stanton and Brenda Waterworth.

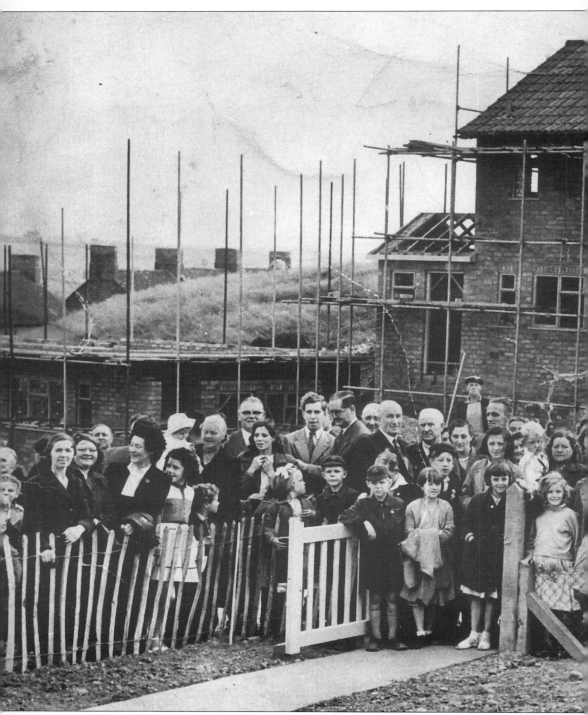

Houses being built at Brindley Heath for the people of the old Brindley Village. Among the crowd are Melvin and Milly Westwood. Note the old row of houses on the left of the photograph.

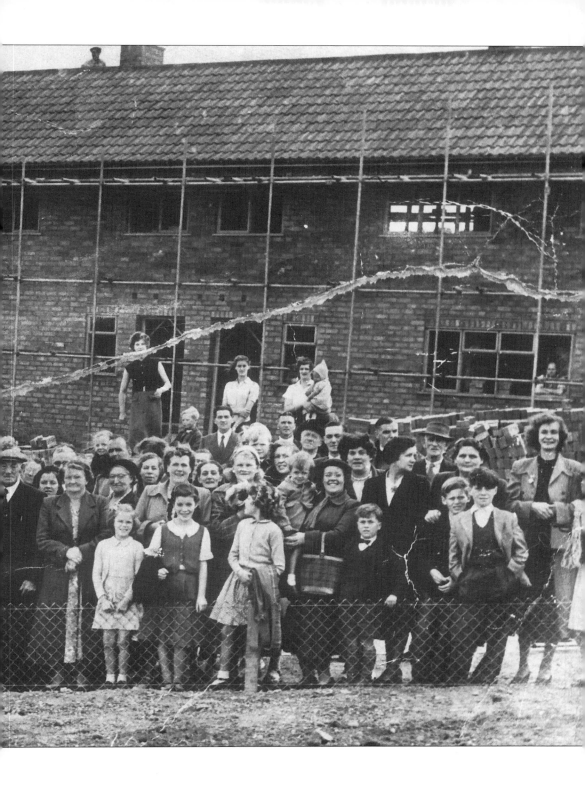

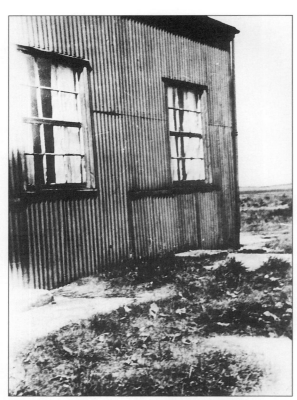

Jim Bullock's tin house at Brindley Village.

Residents of the old Brindley Village in the clubhouse, including: Les Whitehouse, Dick Mason, Terry Leadbeater, Gordon Ghent, Mrs Anthony, Mr Windle, Lol Anthony, Muriel Anthony, Jim Denny, Frank Whitehouse, Bill Harnet, Mrs Windle, Evelyn Kirkham, Don Ford, Roy Grice, Colin Grice, Ian Laing, Malcolm Laing, ? Laing.

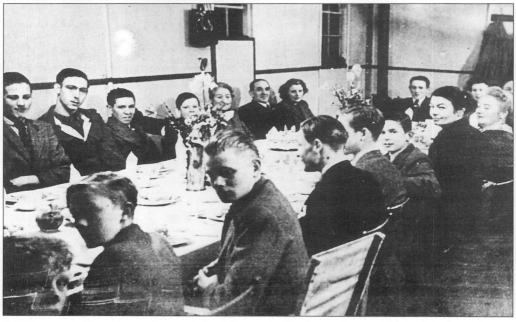

Pat Harnet's pigeon pen at old
Brindley Village.

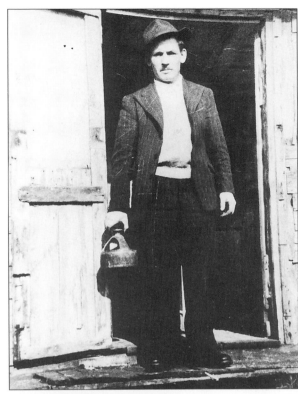

Taken at Brindley Village are:
A. Kirkham, L. Crowder, Jonker
Craddock, Digger Smith, Dick
Mason, George Leadbeater, Jim
Lyons, Frank Dando, Jimmy Denny,
Dyas, Clare, Bill Butler, Jim Bullock,
Peter Ford, Enoch Westwood, Frank
Whitehouse, Dennis Leadbeater,
Tom Whitehouse and Wacker
Craddock.

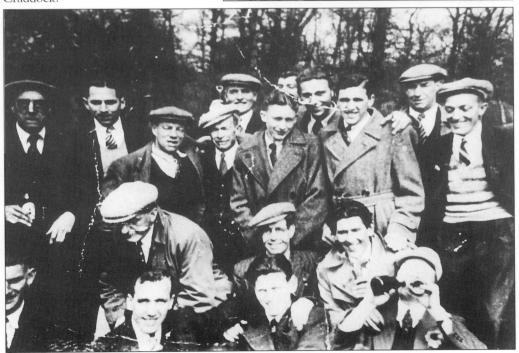

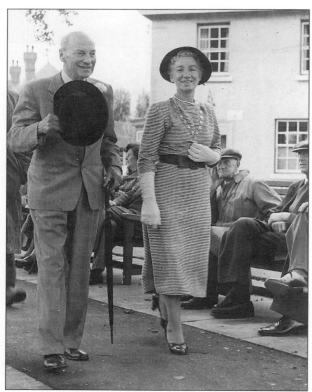

Clement Atlee, Labour Prime Minister after the Second World War, walking across The Green, Cannock, with Millie Rowley, Chairman of CUDC 1955-57, probably during the Labour Gala at Cannock Park.

Aneurin Bevan, then Minister for Housing, with his wife Jennie Lee, the local MP, paying a visit to Jack Phillips. Note the prefabs in the background, a quick solution to the housing shortage immediately after the war.

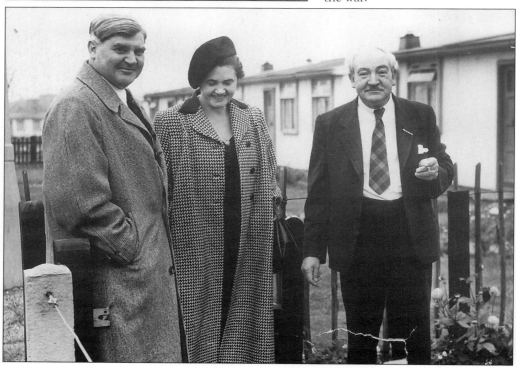

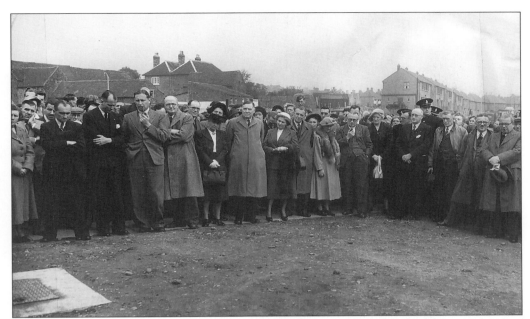

Completion of the 500th house on the Bevan-Lee estate, West Chadsmoor, in the 1950s. Among the crowd are Mr and Mrs Cyril Hodgkiss and Mr Albert Bailey, as well as Mr Speedy. Note the old farm buildings in the background.

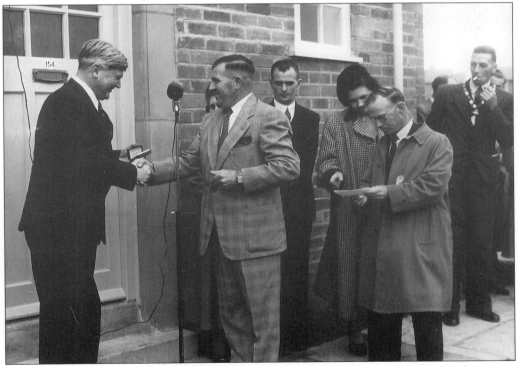

Aneurin Bevan, Jennie Lee, Joe Hampton and Arthur Rowley, presenting the key to the tenant of the 500th council house.

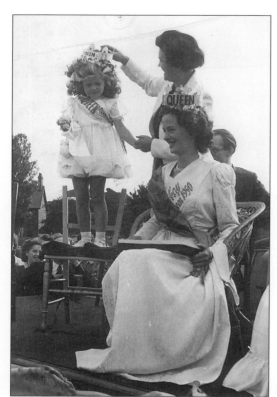

Two beauty queens of 1950.

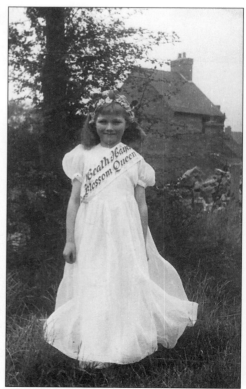

The Heath Hayes Blossom Queen.

Seven
Church and Chapel

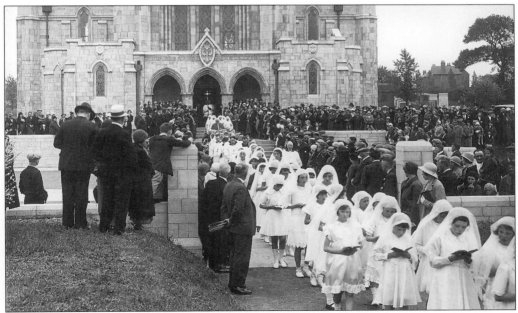

Our Lady of Lourdes Roman Catholic Church, Hednesford. This procession took place soon after the church was completed.

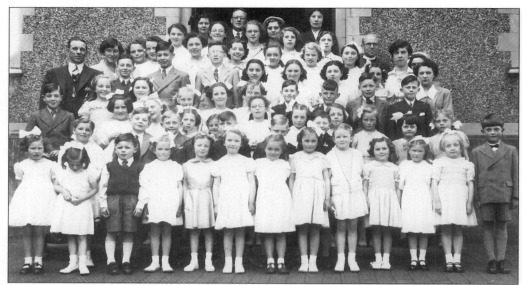

A Sunday School anniversary at St John's Wesleyan Church, Station Road, Hednesford, in the early 1950s. Back row, from left to right: Mrs Welch, Frank Craddock, Sheila Horton, Margaret Craddock. Sixth row: Sheila Merrett, Joyce Griffiths, Margaret Hyden, Janet Seager, Sue Kendrick, Revd Tom Welch. Fifth row: Barbara Ford, Beryl Whitehouse, Jean Shaw, Rosalyn Evans, Margaret Barfield, Margaret Fowler, Jean Edwards, Rita Taylor, Jean Jennings, Maureen Bailey. Fourth row: Joe Hyden, Brian Rowe, David Griffin, Michael Craddock, Betty Whitehouse, -?-, Kathleen Jennings, Maureen Horton, Margaret West. Third row: Anthony Griffin, Doris Bennett, Jean Gregory, Sheila Drinkwater, Maureen Horton, Brian Langston, Christopher Mills, John Thomson. Second row: Christine Hindley, Jean Owen, Carol Clancy, Barbara Brown, Jane Stacey, Mary Bevan, Betty Jones, Dinah Box, Miranda Gething, Phillip Griffin, Carlton Brough, Peter Mills, Brian Jones. Front row: Marie Holden, Ann Parton, David Rhodes, Valerie Amphlett, Verity Wilkinson, Janice Porter, Eileen Fowler, Jennifer Wilson, Jill Craddock, Linda Webb, Sylvia Langston, Lynne Griffin, Ronnie Sutton.

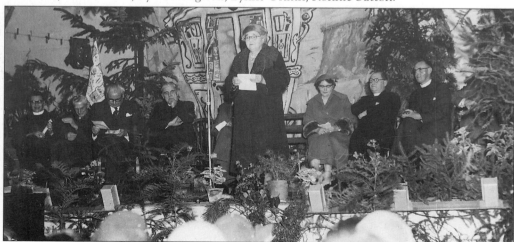

Blossom Time Bazaar at St John's Methodist Church, Saturday 30 May 1964. The opening ceremony was performed by Mrs M.A. Best of Cannock. From left to right: Revd Doidge, G.H. Weaver, Mr A. Bailey, -?-, Mrs Best, Mrs Bailey, -?-, -?-.

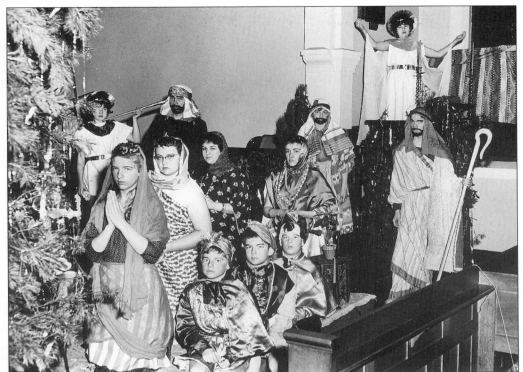

Nativity play at St John's Methodist Church in the early 1950s. In the middle row, from left to right are Anna Gellion, Sheila Vodden, Janet Kendrick and Margaret Fowler. The shepherd in the background is Christopher Gellion and the shepherd with crook is Peter Mills.

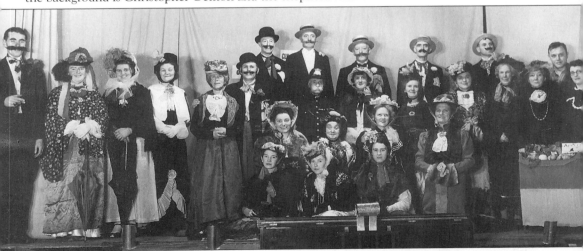

A concert given at St John's in the 1940s. Back row, from left to right: Joe Harrison, Bill Allen, Alf Beddow, Arnold Price, Percy Kendrick, Charlie Gething. Third row: Norman Gellion, Phyllis Pope, Hilda Gething, Mrs Price, Emily Kent, Frank Craddock, J.S. Kendrick (organist and choirmaster), Mrs Allen, Ida Gellion, Fanny Franks, Mrs A. Price, Edith Gething. Second row: Trudie Price, Mrs Barret, Mary Beddow, Mrs Harrison. Front row: Margaret Young, Marjorie Price, Hilda Gough.

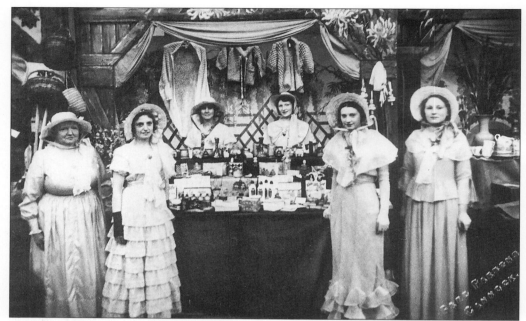

Hednesford St Peter's Church Bazaar, 'All in a Garden Fair', which was held on 7 April 1937. Second from the left is Rhoda Taylor.

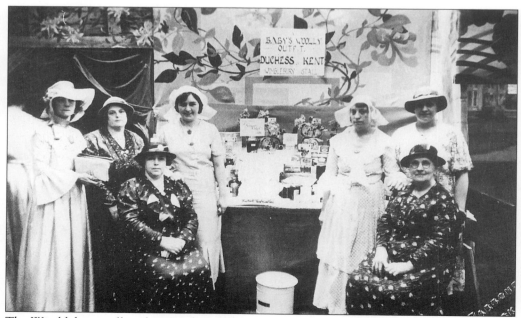

The Wimblebury stall at the same bazaar.

An early 1930s social evening held at the
Electric Palace in Hednesford (now the Co-
op) the proceeds of which were donated to
the Church of England Children's Society.
A representative came from the society,
bringing the costumes with him, and
trained different groups to perform. Back
row, from left to right: Ethel Suthard,
Marjorie Cotterill. Front row: Dorothy
Vernon, Betty Owen and Mavis Leighton.

St Peter's Parish Church, Hednesford. The
laying of the foundation stone of a new aisle
for the church was performed by Lady
Alexander Paget on 18 May 1905. The
architects were N. Joyce and H.T. Sandy of
Stafford. Lady Paget drove from Beaudesert
Hall, through Hazel Slade, by the foundry
at Hednesford, along Station Road and
Market Street and the whole of the route
was decorated for the occasion.

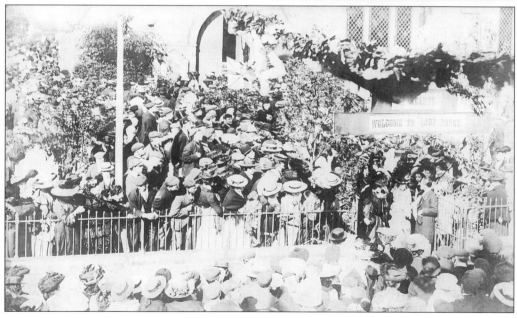

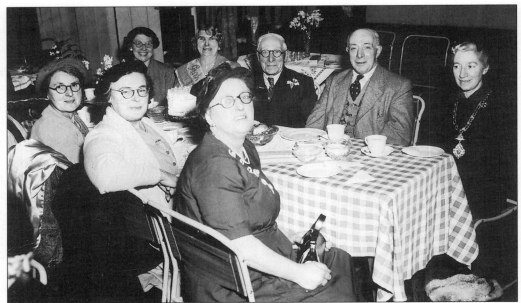

Millie Rowley, Chairman of CUDC 1955-57, attending a function for the Darby and Joan Club at St Saviour's church hall. Back row, from left to right: -?-, Mrs Brookes, -?-, -?-, Millie Rowley. Front row: Mrs Taylor, -?-, Mrs Cund.

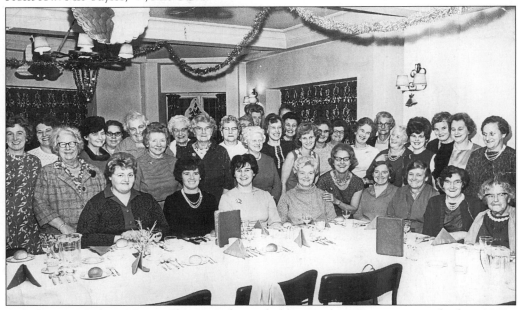

A St Peter's Mothers Union Christmas dinner held at Taylor's Restaurant in the late 1960s. Seated, from left to right: Cherry Poxon, Joan Baggott, Mavis Wilkes, Cynthia Baggott, Vi Tennant, Sister Walton, Mrs Walton, Miss Jones, Mrs Kirkham. First row (standing): Muriel Rogers, -?-, Mrs Haynes, Mrs Cox, Dorothy Smith, Grace Hewitt, Mrs Davies, Mrs Bennett, Julie Smith, Mrs Turley, Elsie Ballance. Back row: Jessie Shaw, Mrs Loach, Mrs Wilkes, Mrs Fowler, Leah Turner, -?-, -?-, Daphne White, Joan Willimot, June Pickerill, Joan Hinks, Mrs Hinks, Mrs Cowlishaw, Mrs Rogers, Mrs Smith.

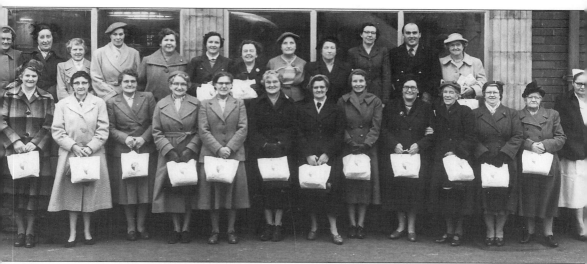

An outing of St John's Methodist Church Women's Fellowship to Cadburys in the 1950s. Back row, from left to right: Phyllis Langston, Doris Bennett, Mildred Jones, Millie Bevan, Daisy Southwell, Mrs Doidge, Freda Wotton, Ada Craddock, Mrs Holden. Front row: Rose Hyden, Mrs Jennings, Mrs Parker, Elsie Craddock, Mrs Lees, Rose Shaw, Mrs Craddock, Elsie Bailey, Mrs Mills, Mrs Kent, Mrs Drinkwater, Mrs Dunning.

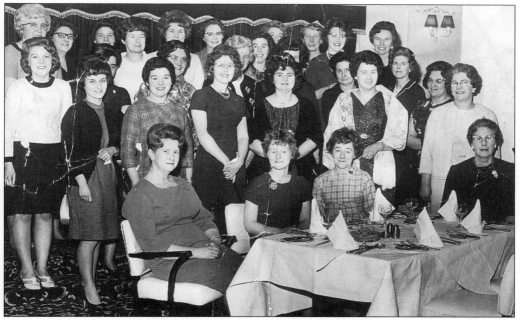

A dinner at the Hollies Restaurant, Cannock, in the mid 1960s for St John's Methodist Church, Hednesford, Young Wives group. Seated, from left to right: Mary Porter, Norma Botting, Josie Hopcraft, Mrs Boulter. First row: Ann Mallen, Jean Oliver, Renee Pountney, Mrs Lees, Hilda Dunning, Hilda Pritchard. Second row: -?-, -?-, Mrs Mills, Mrs Forrest, Vera Corbett, Joy Brookes, Gwen West, Betty West, Margaret Cartwright. Back row: Phyllis Hazel, Eileen Boden, Margaret Craddock, Lilla Wilkes, Norrie Ford, Maureen Macpherson, Renee Amphlett, Mrs Nicholson, Margaret Alcock, -?-.

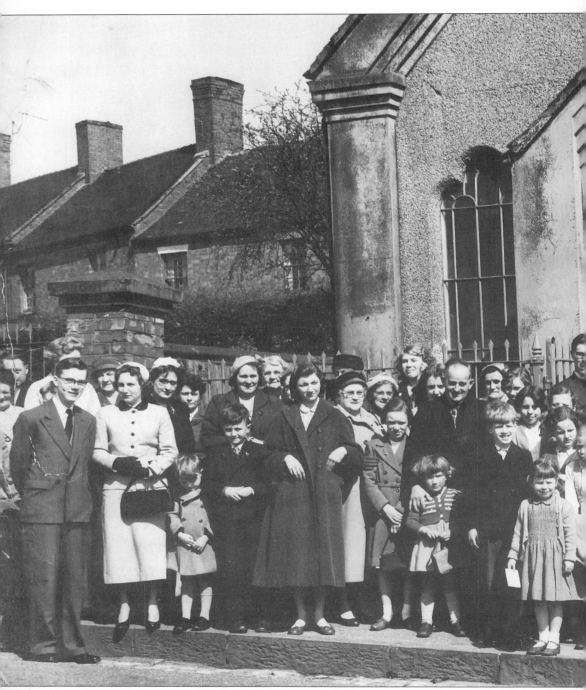

The rededication service after the interior refurbishment of Old Hednesford Methodist Chapel, Hill Street, Hednesford. Note the row of old houses in the background, now the car park and entrance to Kingsmead High School. Back row, from left to right: Gwen White, -?-, -?-, Mrs Davies, Mrs Pritchards, Kit Pritchards, -?-, -?-, -?-, -?-, Joyce Pritchards, -?-, Mrs Barker, Kathleen Barker, -?-, Valerie Bird, Revd Doidge, Tom Brown, -?-, -?-, Mrs Nixon, Mrs Ingram,

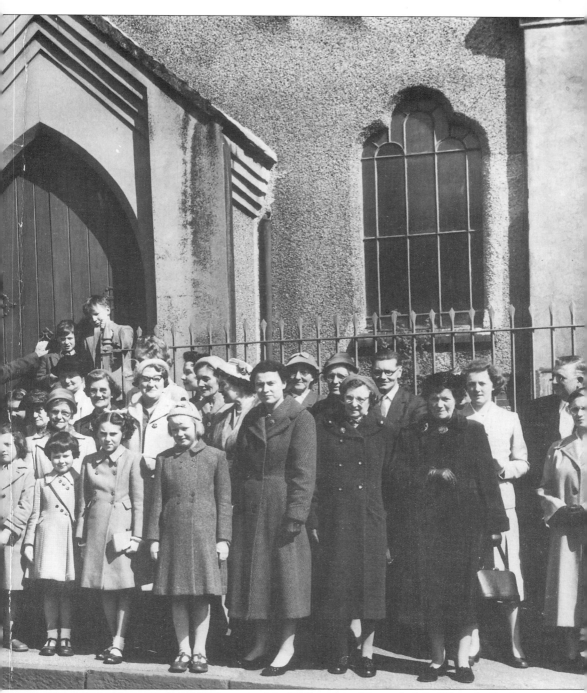

Mrs Plant, June Haycock, Beryl Hulme, -?-, Mrs Wilkes, Mrs Haycock, Mrs Edwards, Pauline Penlington, Mr Penlington. Front row: Frank Jordan (soloist), Brian Hargreaves (organist), -?-, Richard Davies, Robert Davies, -?- (soloist), Susan Barker, Judith Niven, Bill Benton, Lawrence Finch, -?-, Margaret Molloy, Lesley Jenkinson, Rosalind Wilkes, her cousin, Linda Edwards, Hilda Dunning, Miss Pritchards, -?-, Mrs Hall, Mrs Penlington, Mr Pritchards.

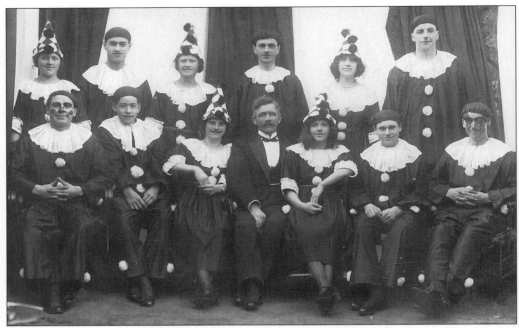

A *Pierrot Troupe* from Bethesda Primitive Methodist Church, Station Road, Hednesford, raising money for charity in the early 1930s. Back row, from left to right: Gladys Purslow, Harold Williams, Ruth Purslow, George Birch, Mrs Tooth, Bill Elsmore. Front row: Tom Jones, Tom Boardman, Gertrude Williams, Ted Purslow, Doris Witts, -?-, Joe Jones.

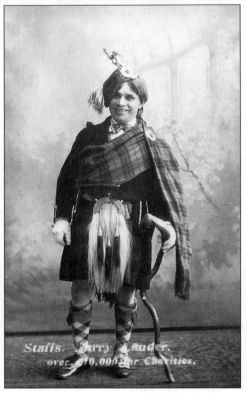

Wilmot Martin, a farmer from Hixon, who was well known for raising money for charity, was given permission from Sir Harry Lauder to use the title 'Staffordshire's Harry Lauder'. He also supplied him with costumes, including the walking stick, and when Sir Harry died, Wilmot spoke in *The Tribute* on the radio. He often performed with the troupe in the previous picture as he was a great friend of Ted Purslow.

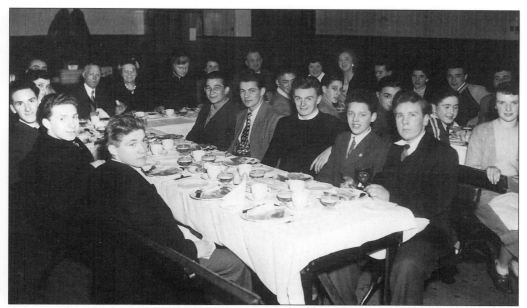

A Christmas party for Torchbearers Youth Club, held in the Salvation Army church hall, West Hill, Hednesford, in 1955. On the left: John Baskeyfield, Arthur Rogers, Ray Hartshorne. Second row: two Hungarian refugees (the last group of people to be housed at the RAF camp on the Chase before demolition) Geoff Benn, -?-, Brian Richards. Third row: -?-, Keith Watkiss, -?-, Brian Hunter, Malcolm Baskeyfield. Fourth row: Jean Watkiss, June Haycock, John Mathews, Brenda Prince, Terry Taylor, Ray Myers. Top table: Mr and Mrs Nicholls, Brigadier Peggy Elliott, Mr and Mrs Baskeyfield.

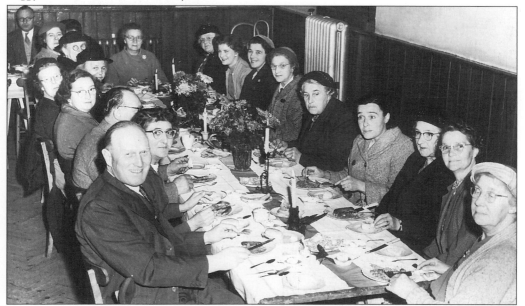

Chadsmoor Primitive Methodist Church Harvest Supper. Left row (nearest camera): Bernard Haycock and Evelyn Haycock; right row (nearest camera): Mrs Ray, Maud Weston, -?-, -?-, Florence Haycock and on the extreme left is Wilfred Smith.

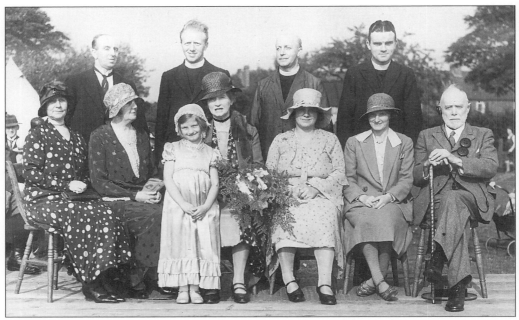

Garden party at St John's Church, Heath Hayes. Seated, from left to right: -?-, -?-, Mrs Ingram-Clarke, Mrs Lafford, Mrs M. Pickerill, Mr Ingram-Clarke (note the hearing aid). Back row: -?-, Revd Lafford, Revd Foster, Vicar of Cannock.

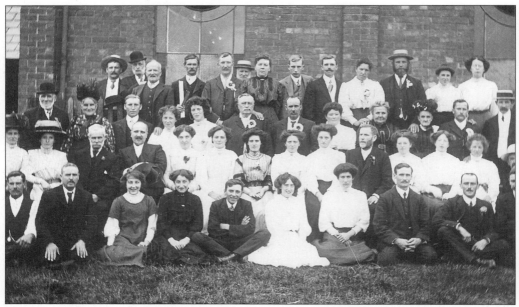

A bazaar at the first Primitive Methodist Chapel in Moreton Street, Chadsmoor. Back row, from left to right: Bob Bailey, Mr Titley, Ben Bailey, -?-, John Haycock, Mr Upton, Mrs Brown, -?-, Isiah Bate, -?-, Mr Candlin, Ann Bate, -?-. Second row: Reuben Onions and wife, -?-, -?-, -?-, -?-, Joe Haycock, -?-, -?-, -?-, Len Broom, -?-. Third row: -?-, -?-, Mr Titley, -?-, Florence Haycock, -?-, -?-, Jesse Bailey, Maiden, -?-, -?-, -?-, Polly Broom, -?-. Front row: Mr Powell, -?-, Elsie Haycock, Eliza Upton, Harry Broom, Lily Bailey, -?-, -?-, -?-, Mr Gallear.

Eight

Life at Work

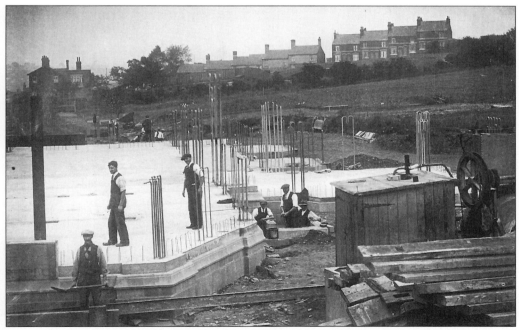

Laying the foundations for the Church of Our Lady of Lourdes, Hednesford, for the Revd Joseph P. Healy, which was opened on 6 June 1934. Note the row of houses going up Church Hill.

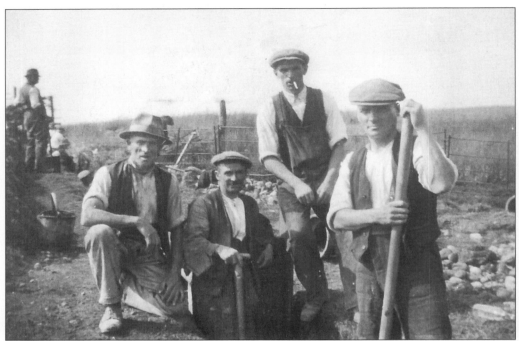

Laying sewage pipes in Rugeley Road, Hednesford. Richard Waterworth is on the far right.

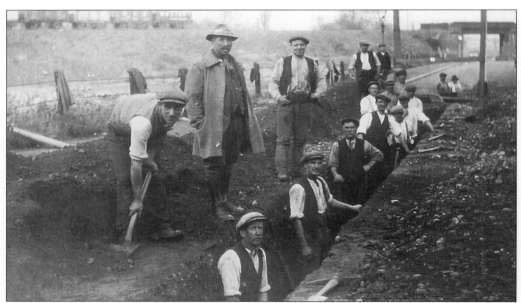

Laying sewage pipes in Rugeley Road, just past the first bridge which was situated by Beverley Hill, and the second bridge at the junction of Rugeley Road and Rawnsley Road. Both bridges are now demolished. The job was known as 'Boswell's' job. On the footpath are, from left to right: Bill Parton, Mr Boswell and Richard Waterworth.

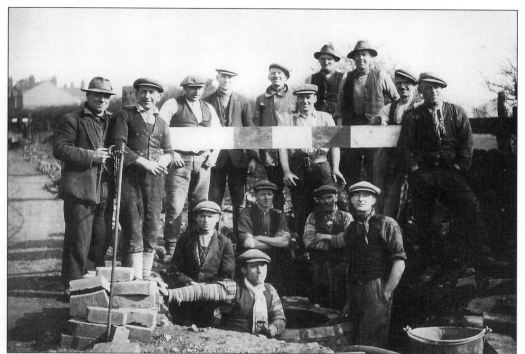

Laying sewage pipes in Longford Road, Cannock; Richard Waterworth is on the far left. These pipes were laid before the sinking of West Cannock No. 5. Pit, as Richard Waterworth helped to build the chimney stack.

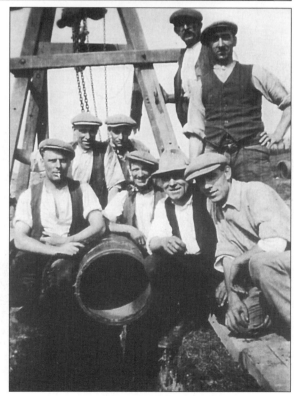

The same group of workmen, showing some of the equipment that was used on the project.

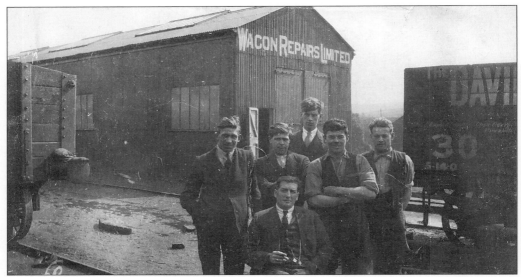

Wagon Repairs Ltd, Station Road, Hednesford. Unfortunately the names are unknown.

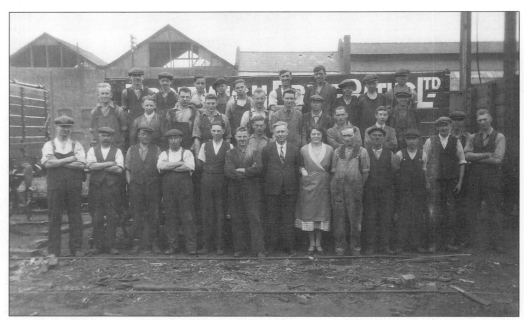

Known locally as 'The Wagon Works', this is another view of Wagon Repairs Ltd, Station Road, Hednesford. Bottom row, from left to right: Billy Spooner, Jack Bevan, Arthur Gretton, Billy Perks, -?-, Charlie Johnson, -?-, Mr Ryder, Betty Ryder, Mr Gripton, Tom Parker, Harry Hunt (from Lower Gornal), Ted Salmons (chief sawyer who lived at Walsall Wood), -?-, Billy Smith. Middle row: Tommy Goodman, (signwriter), Bert Chilvers, -?-, -?-, 'Chinner' Sam Lomas, -?-, -?-, -?-, -?-, -?-. Top row: Norman Thacker (welder), Horace Thacker (striker), Ken Seaman, Arthur Evans, Fred ?, Wilf Butler, Cain Finch, Jos Turnock, Dennis Farr, Bill and Eric Spooner, Les Bates, Tommy Goring.

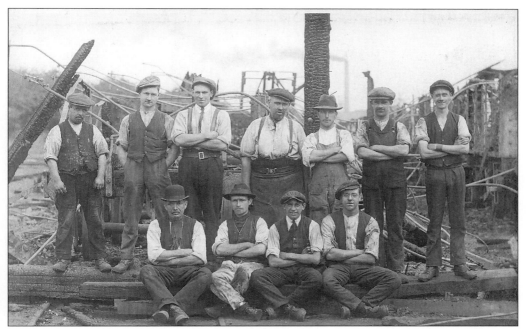

'The Wagon Works' again. Back row, from left to right: -?-, -?-, -?-, -?-, William Perks, John Harvey, -?-. Note the burnt timbers and twisted metal - could this have been the scene of some disaster?

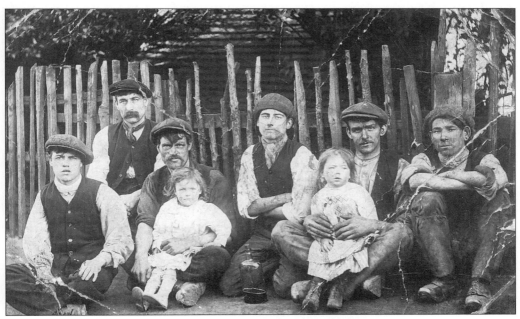

A group of workmen with their children, possibly from Wimblebury.

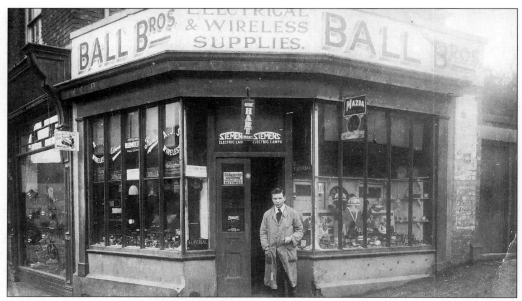

Ball Brothers' shop on the corner of Mill Street, Cannock.

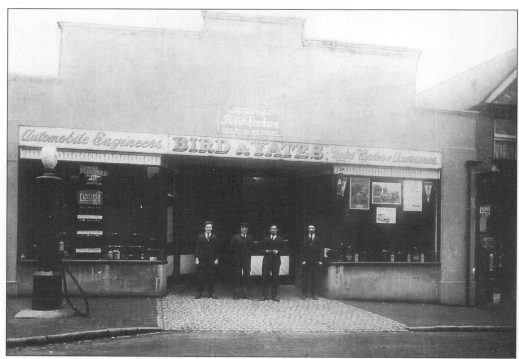

Bird & Yates Garage, Walsall Road, Cannock, opposite the cinema. From left to right: Mr Morgan, Walter Bird, Frank Yates, -?-.

Dave Gee standing outside his shop in Market Street, Hednesford, at a time when you could buy a suit for 50s (£2.50p).

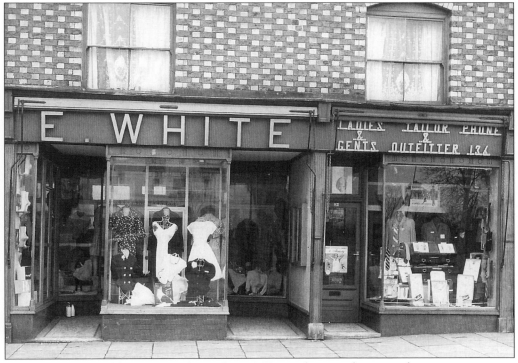

Mr E. White moved from Cannock Road, in 1957, to take over these two shops.

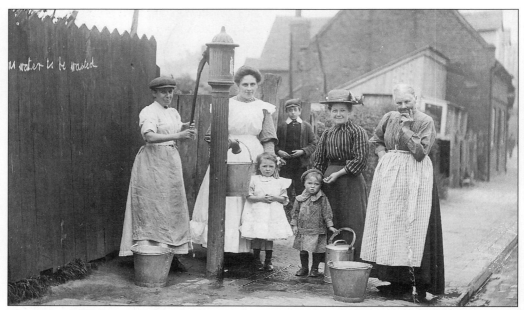

The pump, Mill Street, Cannock. Among the group are Mrs Jackson, her son and Mrs Nixon. The instructions on the fence are appropriate even today.

Canteen staff at Littleton Colliery in 1980. From left to right: Margaret Hall, Elenor Owen, Jean Williams, Barbara Flint, Brenda Hartshorne, Lil Kelly, Iris Hancocks, Jean Wood and Josie Hoban.

A presentation of a gold watch for twenty-five years service at Fafnir Bearings, Littleworth Road, Hednesford. From left to right: Don Cullen, Agnes Baggott, Les Thompson, Arthur Hull, Hazel Cade, Olive Baggott, -?-. The factory started as a shadow factory for Fisher Bearings of Wolverhampton, built on the site of the old Littleworth Brick Works at the start of the Second World War. It was then taken over in 1960 by Fafnir Bearings of Connecticut, USA, extended in 1966 and again in 1974. In 1979 the factory closed and some of the local workforce were transferred to the Wolverhampton works.

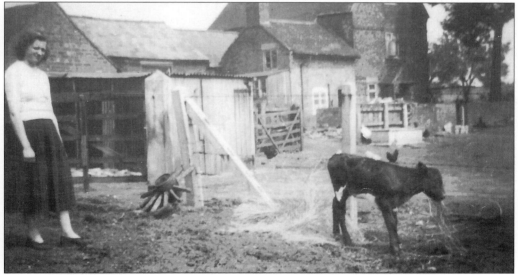

Rose Devall at the farm which is now surrounded by the houses at Hawks Green.

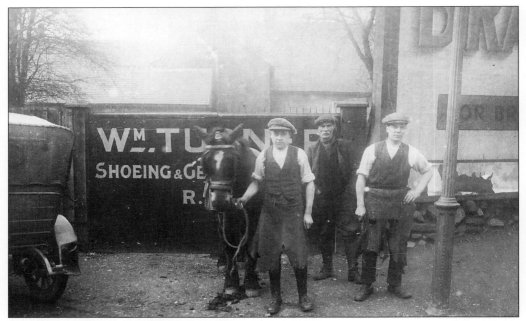

The Forge in Mill Street, Cannock, date unknown.

Alfred Price of Coldwell House Farm, Gentleshaw, date unknown.

Nine
The Mining Industry

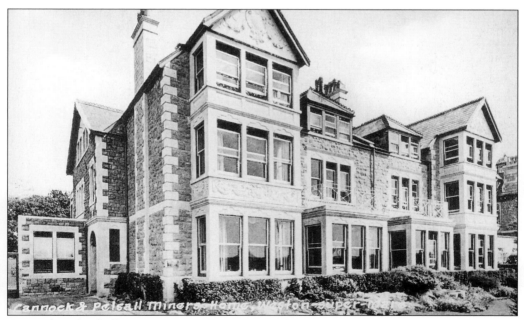

Cannock and Pelsall Miners' Home, Weston-super-Mare.

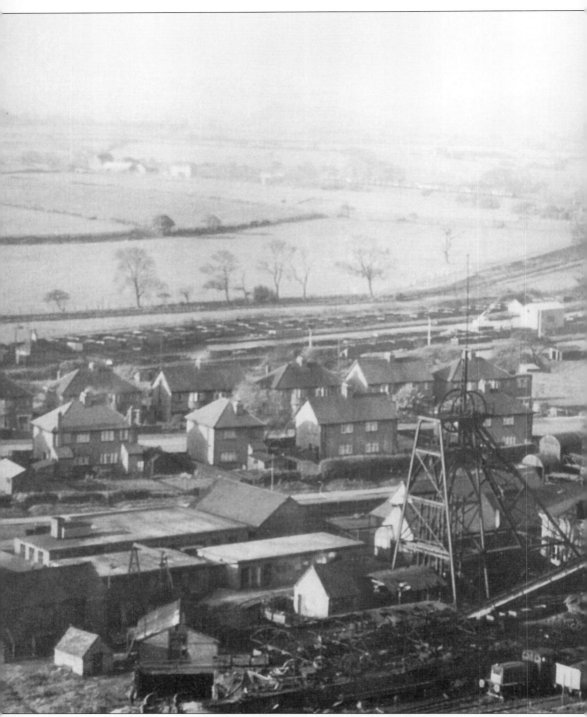

East Cannock Colliery prior to closure, 10 May 1957. The houses in the foreground are in East Cannock Road, and the back row is in Lower Road. Behind the chimney stack is the canal basin, with two coal barges clearly visible. The open fields are now an industrial estate and the

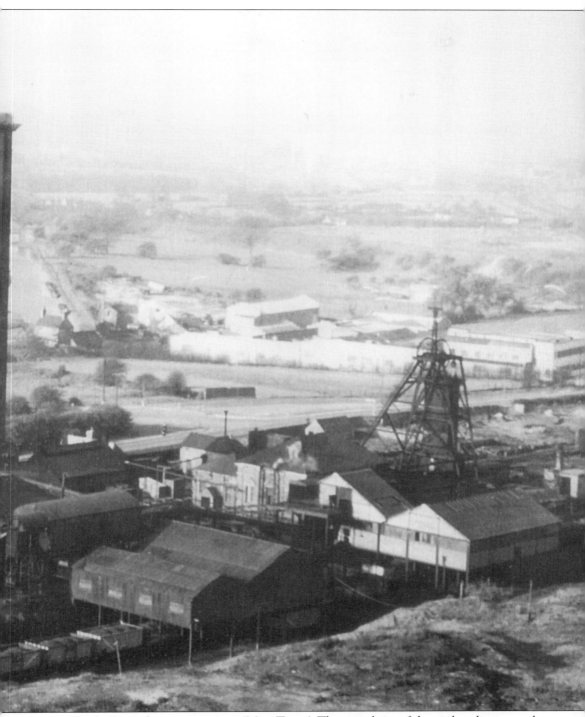

massive Hawks Green housing estate, or 'Mini Town'. The actual site of the pit has disappeared beneath houses. Devalls Farm can just be seen in the distance, top right. (See page 105) The canal, (see page 4) has also disappeared.

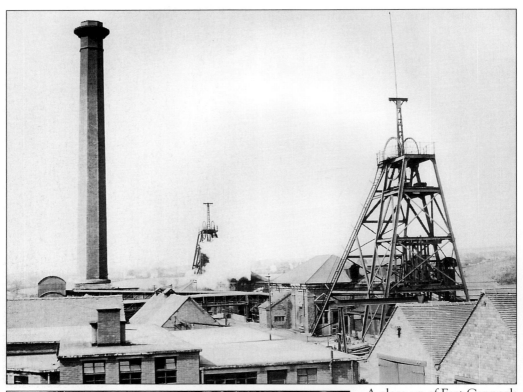

A close-up of East Cannock Colliery prior to closure.

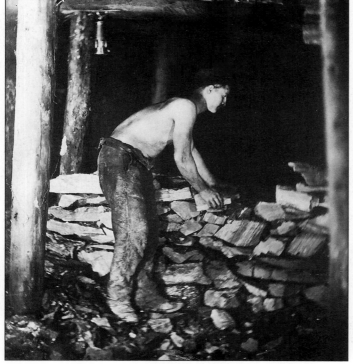

An underground worker, possibly at West Cannock in 1937.

Bevin Boys, named after politician Ernest Bevin, at the miner's hostel in Wimblebury. They were conscripted into work in the pits as an alternative to joining the armed forces during the Second World War.

Valley Colliery Officials and Union men showing how a colliery consultative committee works, for a programme for the BBC. Back row, from left to right: instructor for the BBC, Oliver Cotterell (deputy), Ted Borton (safety officer), Ken Vernon (overman), Norman Leese (check weighman), Jim Drinkwater (overman), Alan Rochelle (manager's clerk), Major Bill Fowke (manager) Jack Jennings (under manager), Austin Cartwright (union member), Sam Morris (union member).

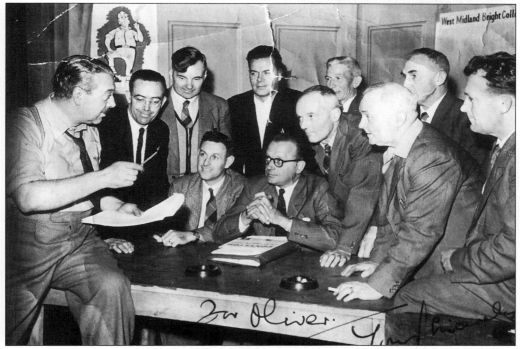

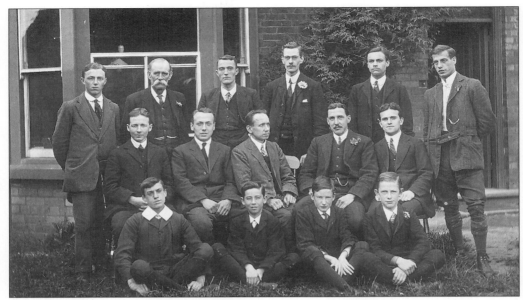

Staff at Littleton Colliery in the early 1900s. 'Boss' Spencer is seated second on the left.

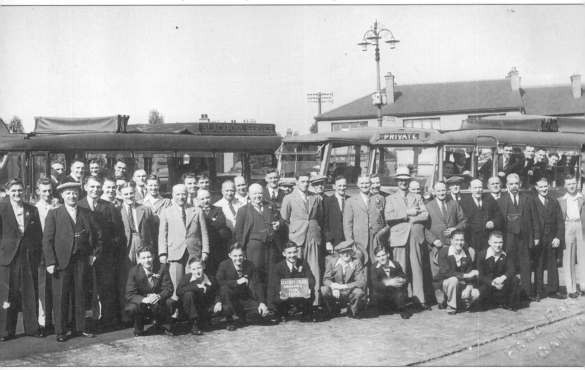

Leacroft Colliery ambulance team at the start of an outing to Blackpool from Queen Square, Cannock, in 1936. The man in the panama hat is Maurice Davies; on the extreme left in a cap is Albert Hill, the head lampman, the man with pipe is George Hood, the one with the handlebar moustache Mr Evans and behind him, Mr Mansell. To the left of George Hood is the manager Charlie Fairley, and next to him stands Herbert Spencer.

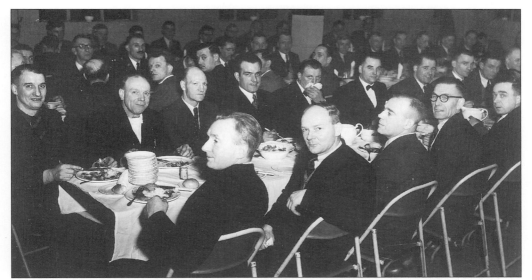

Joint function of Nos. 1, 2 and 5 pits. Front row, from left to right: George Dando, Jack Waterworth, Charlie Hutchings, Jack Dean, Charlie Wassall. Sitting opposite: Jack Deakin, Richard Waterworth, Tom Clarke, Alf Lane, Bert Mathews, Bob Clemson, J. Holford, Arthur Lewis and, two rows further back, is Jack Harvey who was an ambulance officer for the St John Ambulance Division, Hednesford.

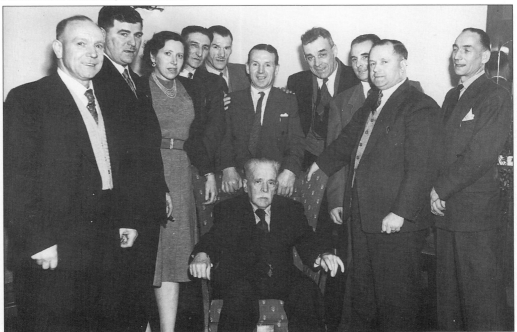

A presentation to Mr Pat Mchlauchlan (senior) on his retirement. He received a plaque and a leather wallet which contained £10 10s 0d. (£10.50). From left to right: Richard Waterworth, Russell Cowdell, Mrs Mchlauchlan (daughter-in-law) George Rogers, Mr F. Nicholas, Ed Kettle, Bill Mchlauchlan, Bob Clemson, T.E. Crellin (manager), Arthur Lewis and sitting, Mr P. Mchlauchlan (senior).

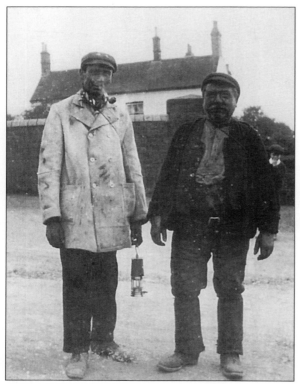

The Revd H.V. Stuart and the stall man who lived in Mill Street, whose name is unknown, walking home over Leacroft canal bridge. The vicar had been working for a week at the coal face at Coppice Colliery, Heath Hayes, to learn to know miners better. It was an event which was the talk of the district and the following Sunday, St Luke's Church, Cannock, was packed to hear his address to the Men's Brotherhood, the title of which was 'Keep out that slack'.

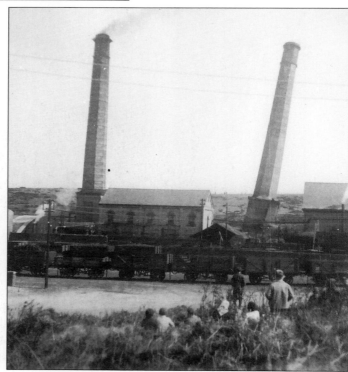

The demolition of a stack at Valley Pit, Hednesford.

Ten

Education

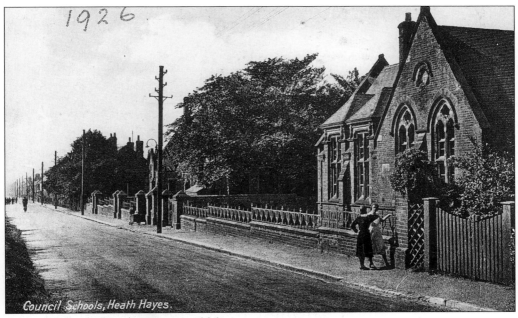

Council Schools, Heath Hayes, in 1926.

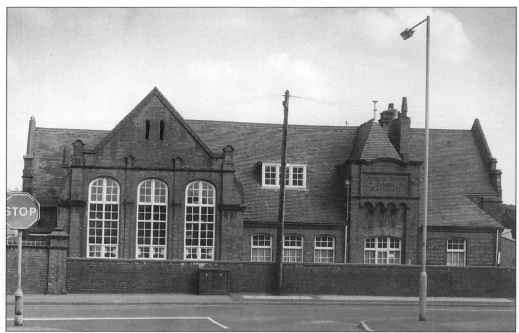

Station Road Infants School, Hednesford, shortly before it was demolished in the 1990s. It is now the site of sheltered housing.

Station Road Infants School May Queen, Hilary Roberts, May 1947. 'I well recall the day Hilary came home and told us she was to be May Queen. However, our delight turned to tears as we realised that we hadn't one clothing coupon between us. Our worry passed away when I remembered my wedding frock in the wardrobe which was taken to a dressmaker friend who transformed it into a dress suitable for the occasion.' (Mrs Roberts)

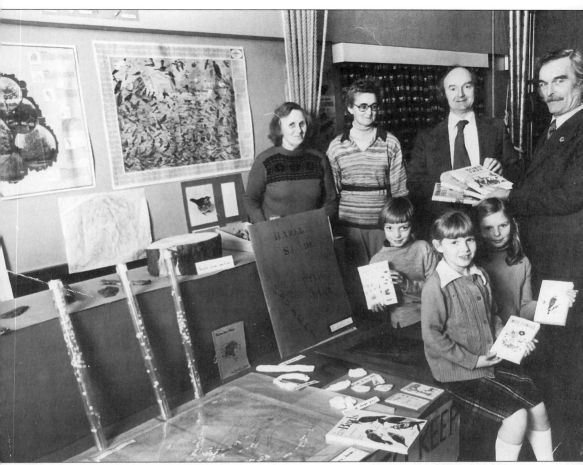

Children of Hazel Slade CP Primary School in 1976. They won the junior section of the Elsa Conservation Club competition for finding as much wild life as possible in a square mile around the school. The prize was £60 for books for the school. Back row, from left to right: Mrs A.S. Brewe, Mrs M. Macpherson, headmaster Mr A. Turner, Mr Tony Baker from Elsa CC. Front row: Michael Sharpe, Samantha Jones, Lisa Baxter.

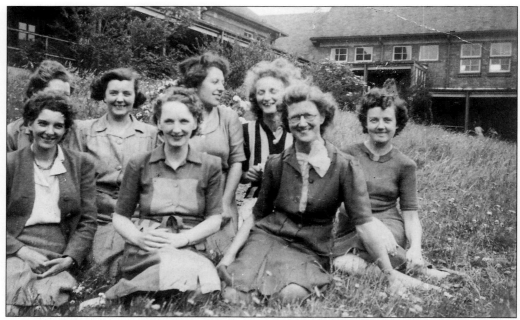

In the quadrangle at Littleworth Senior Girls School, 1939. Front row, from left to right: Miss Moreton (later Bate) Mrs Keddie (headmistress), Marjorie Cotterill. Back row: -?-, Mrs Cardew, -?-, -?-.

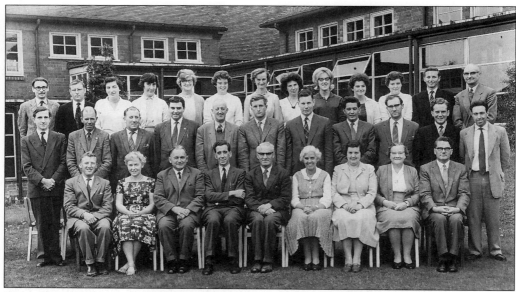

The staff at Littleworth Secondary Modern Mixed School in 1962, the first year the school integrated boys and girls. Front row, from left to right: Mr Essex, Mrs Jutson, Mr Moore, Mr Smith, Mr Cadman (headmaster), Miss Wood, Mrs Cardew, Mrs Bailey, Mr Askey. Middle row: Mr Kembrey, Mr Higgs, Mr Hassall, Mr Williams, Mr Evans, Mr Bennet, Mr Ryan, Mr Chilton, Mr Rowley, Mr Wilkins, Mr Leach. Top row: Mr Ayre, Mr Thomas, Mrs Brentnall, Mrs Metcalfe, Miss Cotterill, Mrs Hargreaves, Miss Harrison, Mrs Hardwick, Mrs Richards, Mrs Parkes, Miss Earp, Mr Tranter, Mr Cartwright.

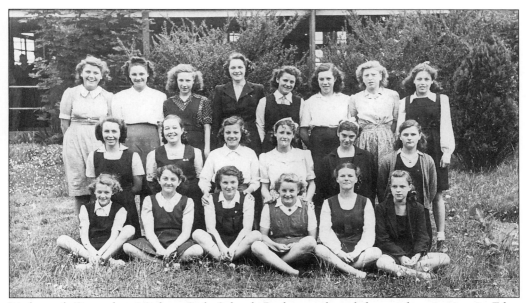

Littleworth Secondary Modern Girls School. Back row, from left to right: -?-, -?-, -?-, Edna Homer, June Beech, -?-, Phyllis Cliff, -?-. Middle row: Hilda Williams, Beryl Hayward, -?-, Margaret Gough, Lois Askey, Elsie Palmer. Front row: Joy Manley, -?-, -?-, Muriel Cooper, Cath Prince, Sheila Moore.

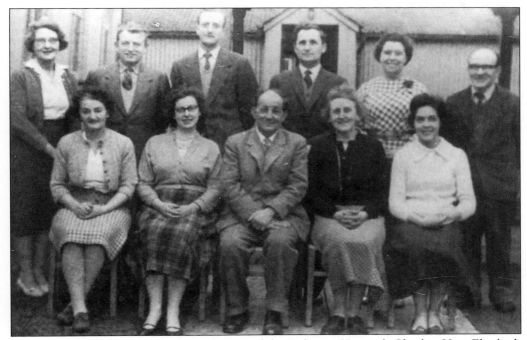

Staff of William Baxter School, on the site of the Isolation Hospital, Cheslyn Hay. Elizabeth Lockett is seated second on the left.

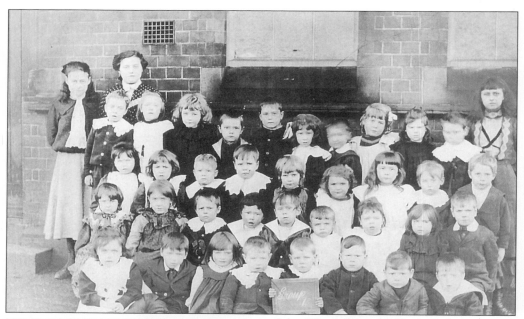

John Wood Infants School, High Green, Cannock, in 1905.

Ada, Lillian and Madge Orme, of 113 High Mount Street, Hednesford. They are dressed in brown corduroy with hats to match, made by Mrs Jennings who lived opposite, in 1933. They hold what must surely be a record, as all three sisters completed perfect attendance for the whole of their school life and were presented with bronze and silver medals for their achievements. Madge also received a bar for the silver medal in recognition of eight years perfect attendance.

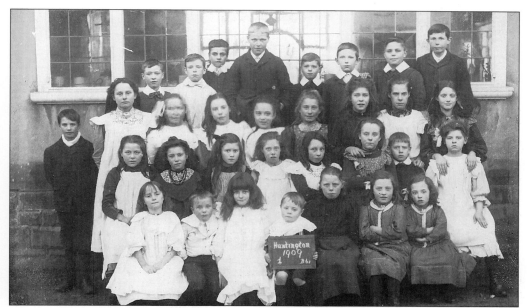

A class at Huntington School in 1909.

Pupils of St Joseph's R.C. School, Hednesford, standing in the playground. The houses are in Hill Street and the semi-detached house on the right was Bishop's Bakery. Back row, from left to right: Joan Banks, -?-, Elizabeth Lockett. Middle row: Pauline Hodson, Pauline Baggott, -?-, -?-, Janet Mears, -?-, Doreen Schofield. Front row: John Lockley -?-, -?-, -?-.

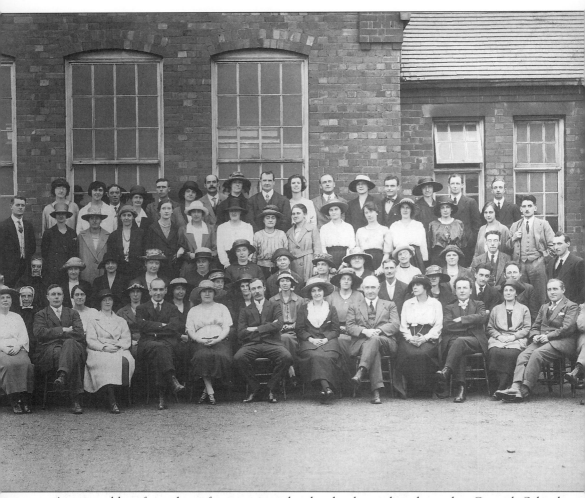

An assembly of teachers from various local schools, gathered at the Central School, Chadsmoor, between 1921-1924. Top row, from left to right: fourth Nell Pickerill (St. Peter's), Mr Johnson (West Hill Boys), -?-, Mr Garbett (Headmaster Heath Hayes Boys), Miss Wootton (Headmistress West Hill Girls), Mr Goring (Headmaster West Hill Boys), Ethel Suthard. Next row: thirteenth Bess Walker (Heath Hayes Infants) Annie Kent (St Peter's), Jack Lowry (Central School). Next row: Sister Anselm (St Mary's Convent) sixth Mrs Jones (Heath Hayes Infants), Miss Hanning (Headmistress Heath Hayes Infants), -?-, Mrs Edgar Wright (Headmistress St Peter's Infants), -?-, -?-, Mr Henderson, Mr H. Bailey (St Peter's). Seated: Miss Rhodes (Headmistress West Hill Infants), -?-, Mr Rowley (Central School), Mrs Swarbrick (Station Road Infants), eighteenth Miss Orton (Central School, Headmistress Heath Hayes and first Headmistress of Littleworth Senior Girls), Mac Wright, -?-, -?-, -?-, Fred Sambrook (Central School), Hyla Turner (West Hill Boys).

Eleven

The Chase

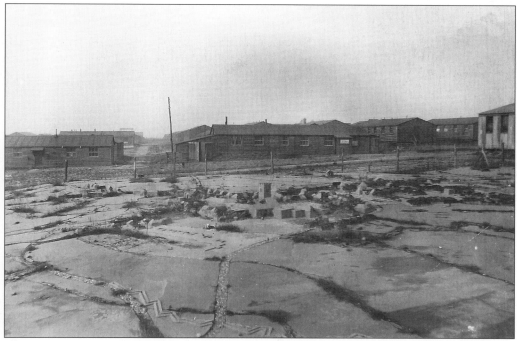

A scale model of Messines Ridge, constructed by German prisoners under the direction of New Zealanders during the First World War at Brocton Camp. The details were accurate, with zig-zag trench systems and road networks, and brick fragments to represent farms, cottages and the village of Messines. It was presented to Stafford by the New Zealand Rifle Brigade when they left in 1919, hoping it would be preserved. This was not the case and it rapidly became overgrown. The corrugated iron shelter and flagpole remained intact until the Second World War. (See *A Town for Four Winters* by C.J. and G.P. Whitehouse).

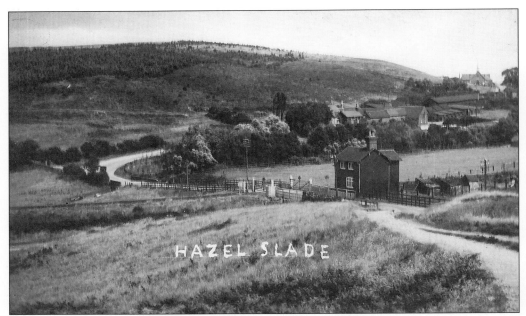

Hazel Slade, Hednesford, with the level crossing and house in foreground, and the mineral line coming from Cannock Wood Colliery. The trees in the background are young, which dates the scene to the late 1920s.

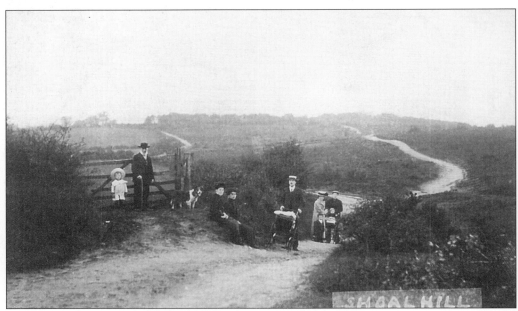

An unusual shot of Shoal Hill, showing tracks to the White Lion public house from 'Arnotts Grave' in the early 1900s. Arnott was reputedly hung as a highwayman and stealer of sheep.

124

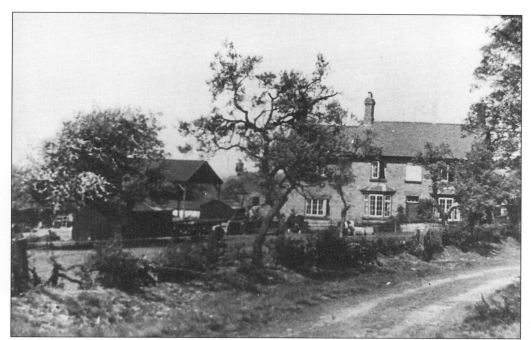

A farm at Shoal Hill.

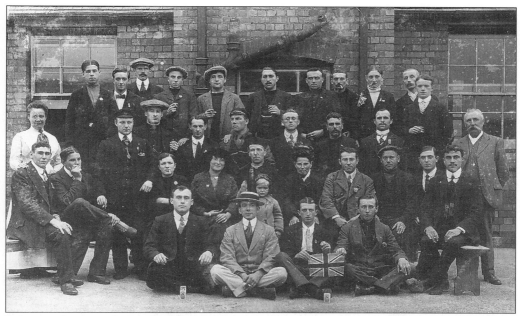

Belgian refugees at Cannock Workhouse during the First World War, with Father O'Keefe and Master and Matron Mr and Mrs Spires; Dininage is next but one to Father O'Keefe. It is fascinating to note that almost without exception, all the men have a cigarette and looking closely, the two small items on the ground at the front appear to be packets of Player's cigarettes.

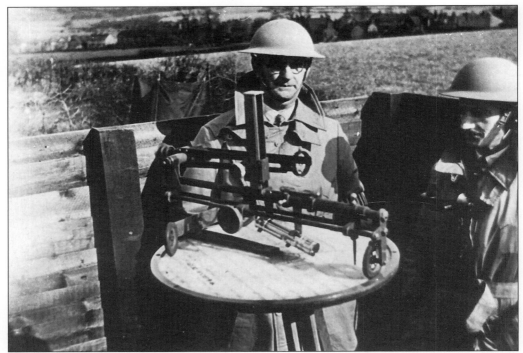

The Air Raid Observer Corps stationed at Calving Hill, Cannock, during the Second World War, with Bill Ball in the centre.

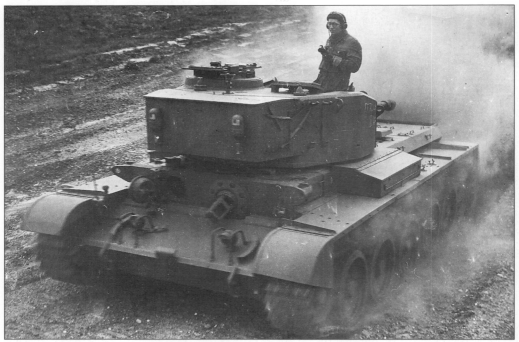

Testing tanks made by the English Electric Company, Stafford, on Cannock Chase, for use in the Second World War.

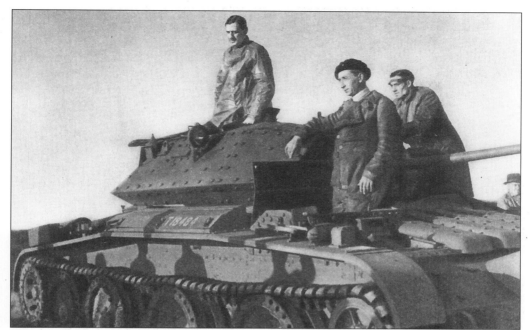

On 21 October 1941, General de Gaulle made a tour of the works at English Electric and being an expert in armoured warfare, was interested in the tank factory. He later rode in the turret of a Covenanter tank at the testing ground on Cannock Chase. The man wearing the beret is Jim Macpherson, one of the men employed to drive the tanks over the rough terrain.

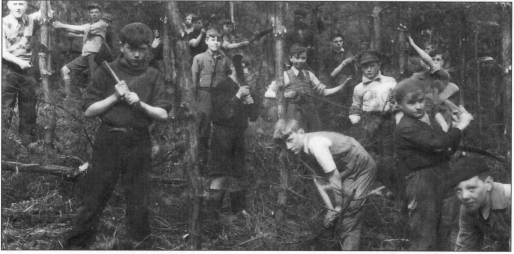

A fifty-strong party of boys aged from 14 to 15 years from Littleworth Senior Boys School, including evacuees from Margate, were employed by the Forestry Commission during 1943 to lop all the branches off the trees as far as they could reach. They earned £4 per week and were provided with accommodation in a barn on the Stafford Road, the Second Lodge or under canvas, with their meals being cooked in the open by the army. This exercise took place between the First Lodge and Stafford Road, around Pottal Pool. Due to the shortage of man power, the exercise was carried out again in 1944. Some of the boys were Alex White, Gilbert Searle, Ken Pockett and Tony Rogers.

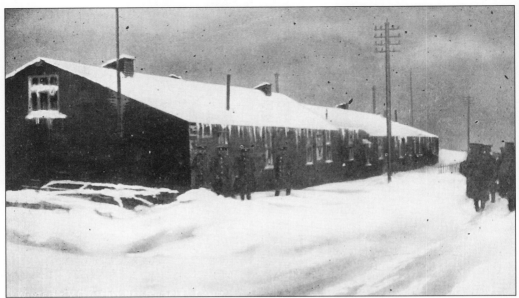

Winter at Rugeley camp during the First World War, showing the YMCA Hut No. 1. Depot.

A postcard sent in 1918 to his mother in Stone, Staffs, from 'Harry', thanking her for a parcel and informing her that 'we are going on Friday'. Departure was usually to France and the trenches.